MW00773347

Finding a Likeness

Finding a Likeness

PENGUIN PRESS
An imprint of Penguin Random House LLC
penguinrandomhouse.com

Image credits appear on pages 331–341.

LIBRARY OF CONGRESS CATALOGING-
IN-PUBLICATION DATA

Names: Baker, Nicholson, author.
Title: Finding a likeness : how I got
somewhat better at art / Nicholson Baker.
Description: New York : Penguin Press, 2024.
Identifiers: LCCN 2022059380 (print) |
LCCN 2022059381 (ebook) |
ISBN 9781984881397 (paperback) |
ISBN 9781984881403 (ebook)
Subjects: LCSH: Art—Psychology. |
Baker, Nicholson—Knowledge and learning. |
Art—Technique.
Classification: LCC N71 .B26 2024 (print) |
LCC N71 (ebook) |
DDC 700.1/9—dc23/eng/20230825
LC record available at https://lccn.loc
.gov/2022059380
LC ebook record available at https://lccn.loc
.gov/2022059381

Printed in China

10 9 8 7 6 5 4 3 2 1

Book design by Claire Vaccaro

For Margaret

Finding a Likeness

Hi, this is me. Welcome to my book *Finding a Likeness*. I recently traced this self-portrait with pen on a thick piece of paper taped to my computer screen.

I live in Maine, near Bangor, with my wife, Margaret, and we have two grown children, Alice and Elias. I'm sixty-seven, and I write books for a living.

My last book, *Baseless*, was about horrible government programs that happened in secret a long time ago. When I finished writing it, in May 2019, I was wiped out.

I needed a rehabilitation program. A less bleak way of looking at the world.

BASELESS

**MY SEARCH FOR SECRETS
IN THE RUINS OF THE
FREEDOM OF INFORMATION ACT**

NICHOLSON BAKER

I already had a hobby: photography. I rented fast lenses and took photos with a wooden folding bellows camera, and a Bronica camera, and several digital cameras, and iPhones. Like everyone else, I've taken tens of thousands of pictures. They happen so fast: you stop, take the picture, move on. A stairway in our old house, a tree near our new house, some leaf shadows, a bowl of cherries. Click, done.

Sometimes I'd look at the old photos and think, It's not enough to take the picture. I want to scoop more, squeeze more, out of these images. I want to live more slowly through the snatches of past life they hold.

Sometimes I thought, Maybe I could learn how to paint them?

My father paints. He and my mother met in art school at Parsons School of Design in New York.

For a while, when I was little, his advertising business was in the basement of our house in Rochester, New York. All kinds of art was going on

Douglas Baker, *Handel: Solomon*, poster

Douglas Baker, *Britten: War Requiem*, poster

Gardener's Chair

down there. There were T squares and art markers and Rapidograph pens and drawers full of rub-off lettering.

In 1967, he designed an artmobile that toured Rochester schools. Its theme was "An Adventure with Light." It was painted black inside, with ramps and baffles and glowing displays, and a light organ. Tens of thousands of children went through it, including me.

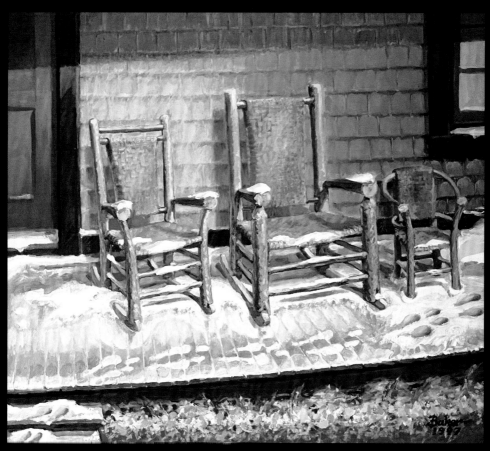

Porch Chairs

After Parsons School of Design, my mother got a job as a colorist at a fabric company in New York, choosing the color combinations ("colorways") for fabrics. When we moved to Rochester, she began teaching art classes at the Memorial Art Gallery, and she gave my sister and me lessons. She showed us how to paint

Ann Baker, flat design,
Parsons School of Design

Colorways for two fabric patterns, Greeff Fabric

a sky in watercolors, using a wash. And she had us do big scribbly gesture drawings on newspaper pages, and very precise contour drawings, following Nicolaides's *The Natural Way to Draw.* She taught us the phrase "still life."

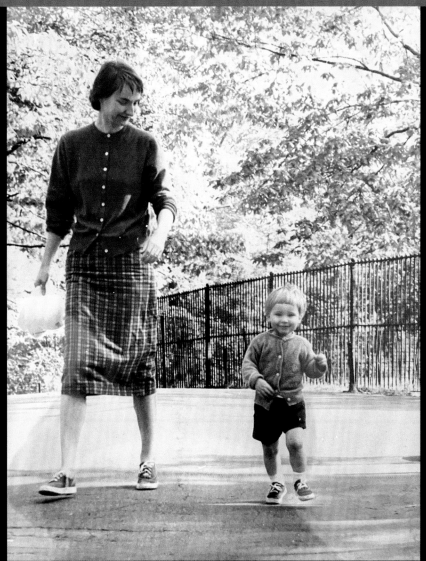

My mother and me at the Bronx Zoo

In junior high school I learned perspective, painted a whooping crane, and copied Chinese dragons and newspaper cartoons. I spent an afternoon making a detailed still-life drawing of one of my old Sears work boots. I can't find the drawing now, but I remember being happy with how it turned out—how the laces looked when they emerged from the shadows of the grommets—even though the overall proportions of the boot were squashed.

After the work boot, I tried to draw a face—my sister's face—and I failed. Everything was misplaced and misshapen. My sister came out looking like a blond crocodile.

Since then, until 2019, I'd drawn a total of maybe four pencil drawings. The last one was in 2001, on my wife's birthday. I was reading John Ruskin at the time, and I drew some vaguely Ruskinian plants growing out from under a layer of rocks at York Harbor Beach. Ruskin is the one who said, "If you can paint one leaf, you can paint the world."

I gave my wife the drawing and she kept it.

Leaf drawings
by John Ruskin

My wife is an artist. She cuts pieces of origami paper with scissors and glues them down.

I feel strange calling her Margaret, so I'll call her M.

She also draws with colored pencils and weaves fabric.
She doesn't make a big deal of it, she just does it.

In August 2019 I sent a book proposal to my editor. "I'm consumed by the idea of learning to paint," I said. "My ultimate dream is to be able to paint a white tablecloth set for lunch in a green and dappled shade." I also said I wanted to find artists I didn't know about, study their work, and try to master some of their techniques.

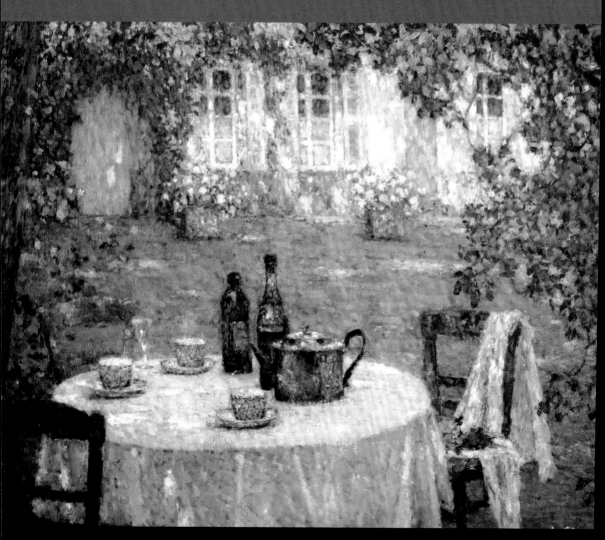

Henri Le Sidaner, *La Table au Soleil*

My editor said yes. Write a book about learning to paint dappled shade. I felt a shiver of fear. What if I failed? I'd never used oil paints before.

On the other hand, I knew what an oil painting was. I'd flipped through art books; I'd
been to museums. I knew I liked John Singer Sargent and Mary Cassatt.

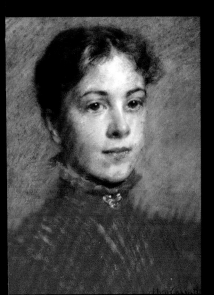

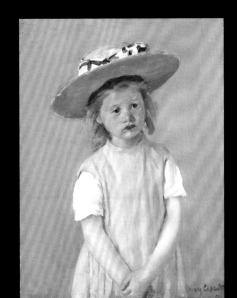

And I knew I liked Édouard Vuillard's interiors.

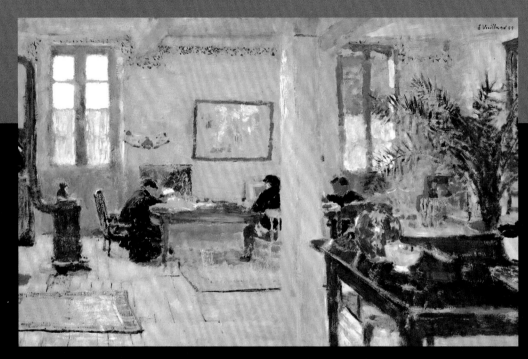

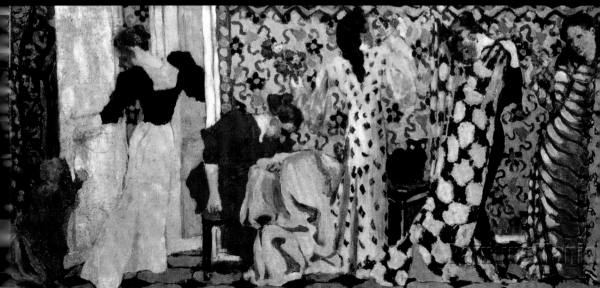

And Gustav Klimt's trees.

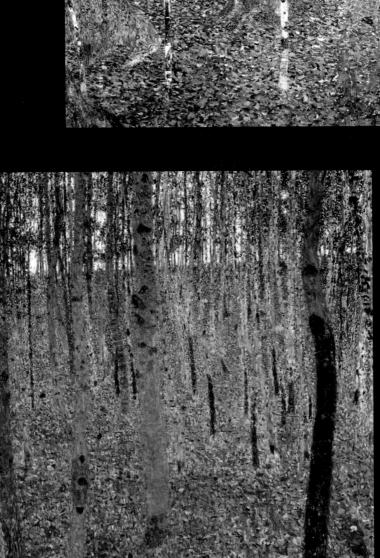

Beginning

2019

August 2019. So my task was to learn to paint and write a book about it.

Fortunately there was research to be done. That would delay the moment when I actually set brush to canvas.

The first thing I did was to fast-forward through innumerable YouTube how-to videos. I also spent hours on Pinterest, and I bought some how-to-paint books. This took up the month of August.

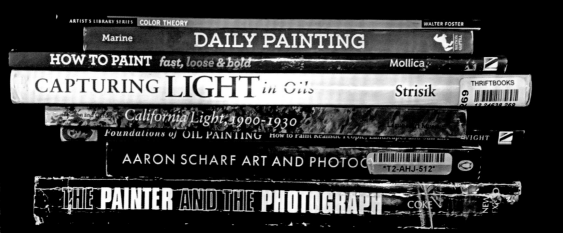

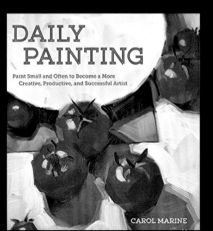

DAILY
PAINTING

Paint Small and Often to Become a More
Creative, Productive, and Successful Artist

CAROL MARINE

Carol Marine's book *Daily Painting* had a heady message: "Paint small and often." I liked her juicy-looking, slightly linearized apples on a table.

Patti Mollica's *How to Paint Fast, Loose & Bold* had a painting of juicy-looking, slightly linearized martinis in a glass.

Mollica's watchword is "Thick buttery paint, big fat brushes."

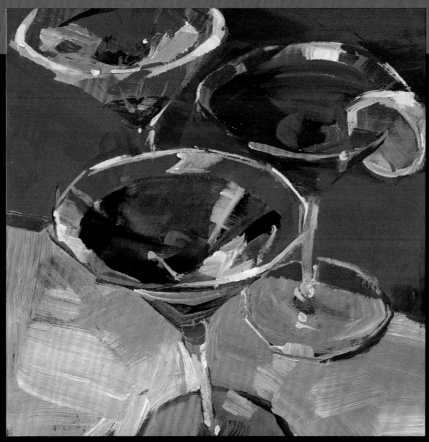

On YouTube I watched portrait painter Mark Carder paint a jar of linseed oil in forty-five minutes, and I listened to him explain how to use an interesting wooden machine called a proportional divider. His advice was to "paint ugly." Don't try to paint every detail, and don't blend your colors—leave them jumbled, just as John Singer Sargent had, he said.

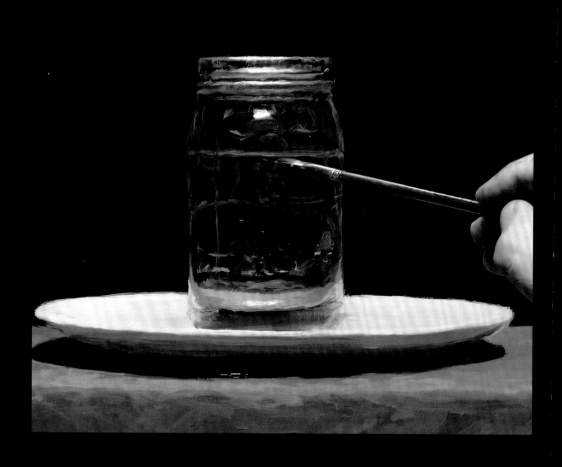

How to paint a portrait - REALISTIC PORTRAIT PAINTING TECHNIQUES in oils

21:43 / 27:47

Australian prodigy Andrew Tischler, wearing a baseball hat, demonstrated how to use cobalt teal, titanium white, and phthalo turquoise to paint a convincing wave, with light "exploding" within it.

In another video he offered some of his favorite hyperrealistic portrait painting techniques, including the painting in of tears with the tip of a round synthetic brush.

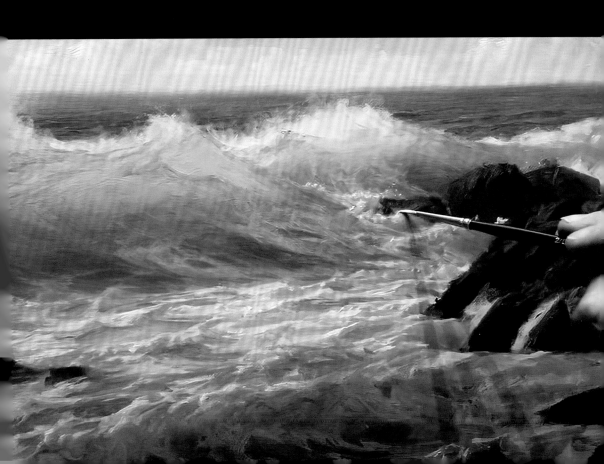

Romantic sentimentalist Vladimir Volegov, "Master of Light," dabbed and stroked into existence a lightly frocked backlit woman, ankle deep in virtuosically glittering water.

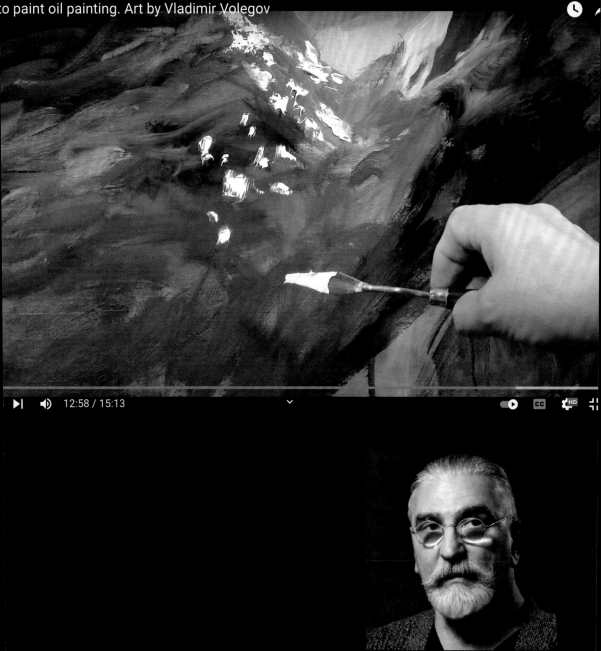

Pinterest proved to be uncannily good, better even than YouTube, at learning my tastes and helping me discover art I liked by artists I didn't know about. Through Pinterest I found Carole Rabe, Karen O'Neil, Zinaida Serebriakova, Quang Ho, and Cecilia Beaux.

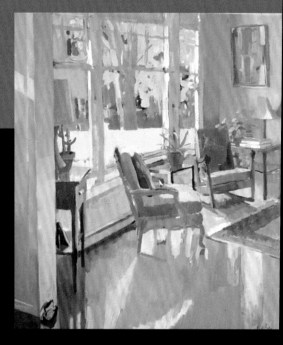

Paintings by Carole Rabe

Carole Rabe, of Massachusetts, paints light-filled rooms and halls with shiny floors. When I interviewed her by phone, she said that most of the paintings are of her former house in Natick. After her husband died several years ago, she remarried and moved to a new house, which has wooden ceilings. The light is different. Now she paints fewer interiors, and more plants. Her plants are good too.

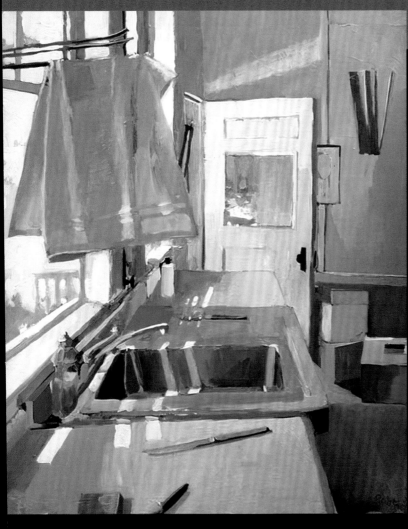

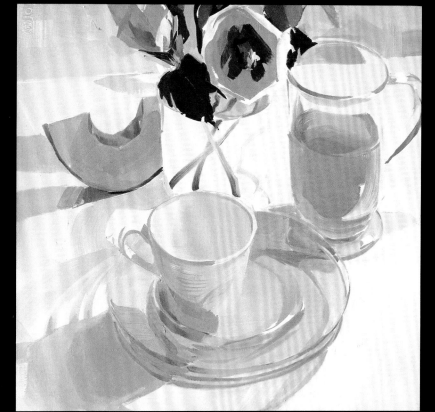

Karen O'Neil teaches at the Art Students League in New York City and makes ultra-clean still-life coruscations of fruit, flowers, and glassware.

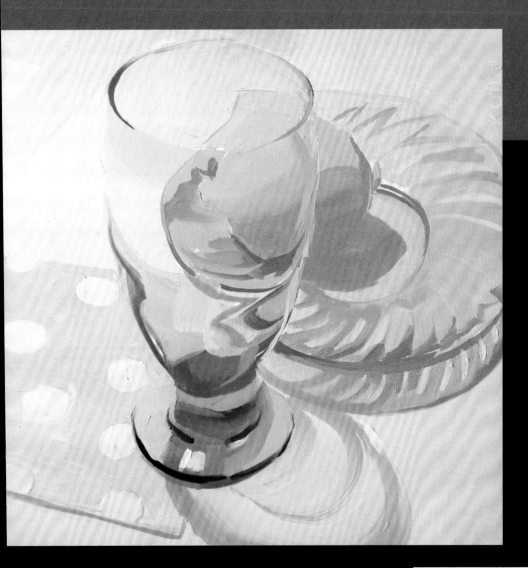

Zinaida Serebriakova (1884–1967) painted smiling, sparkling self-portraits. She had a sad life, though. Her husband died of typhus, her family's estate was plundered, and she was separated from two of her four children for many years.

Winter Cree

Quang Ho, *Arrangement with Dahlias*

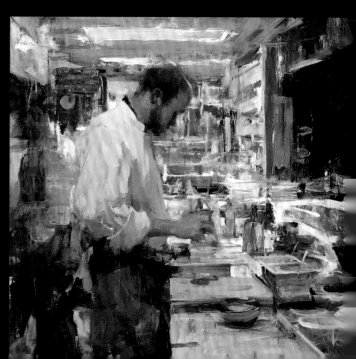

In the Kitchen

Quang Ho paints flowers, snowy trees, and restaurant chefs, among other things. *In the Kitchen* is a study of poise amid culinary urgency and clutter. Ho left Vietnam with his mother and four brothers in 1975 at the age of eleven. At sixteen, he had a one-man show in Denver, Colorado; two years later, his mother was killed in a car accident, leaving Ho to mind his younger siblings. "They all grew up pretty good," he told a reporter.

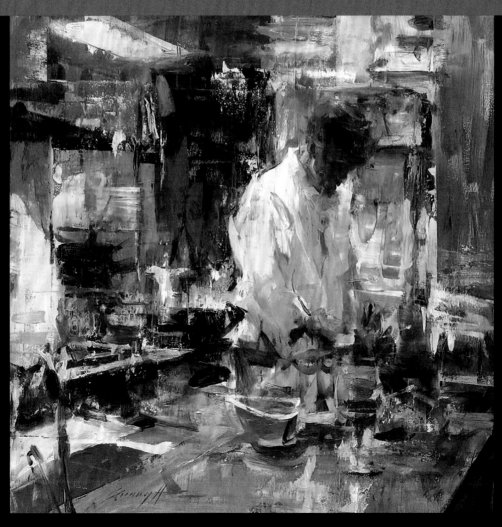

Mizuna

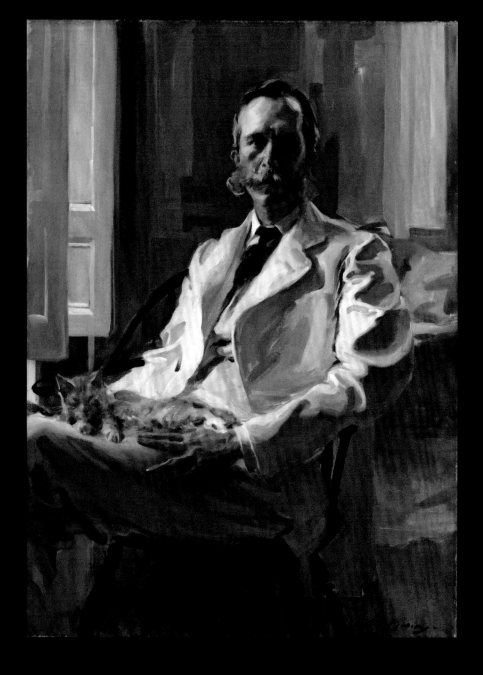

Cecilia Beaux (1855–1942) was my biggest early discovery. I whispered "Oh, wow" when I first saw her large portrait of her brother-in-law, Henry Drinker, painted in 1898. The gentle light in the room—the playful, easy handling of the folds of Drinker's Mark Twain–style suit (he was a Philadelphia lawyer). The splayed fingers, and the perfect sleepy cat in Drinker's lap. And those explosive, absurd muttonchop side whiskers, faithfully rendered.

Here's another good portrait by Beaux, *A Little Girl*.

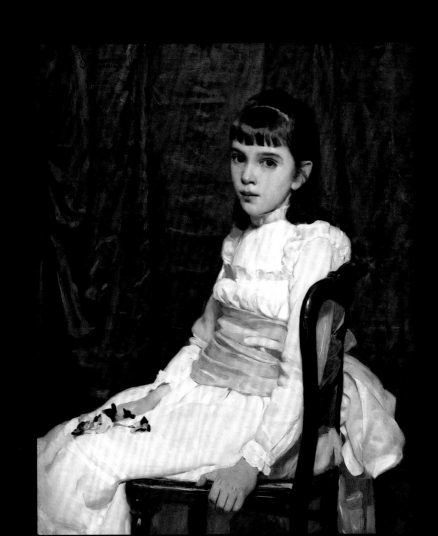

Beaux's mother died when she was a newborn, and her father left her with relatives in Philadelphia and sailed for France. She won all the medals at the Pennsylvania Academy of the Fine Arts and studied with Bouguereau in Paris.

One of her favorite models was her niece, Ernesta, Henry Drinker's daughter. She painted Ernesta as a small child in white, as a woman in white, and as a woman in a turban. The painting of her in a turban is part of a larger work that somebody cut into pieces: one piece was Ernesta's head and torso; the other preserved her pointy satin shoes.

n Page,
Birches

McLoons

September 2019. Eventually I realized that browsing Pinterest and watching time-lapse art videos on YouTube, although pleasant ways to spend the time, weren't going to make me a painter. I had to do some actual painting. After finishing the last of eight hundred endnotes to *Baseless*, I signed up for a four-day plein air (i.e., outdoors) workshop with Colin Page, a painter who lives in Camden, Maine, and has a gallery there.

BIW Cranes

Colin was okay with the fact that I'd never painted before. He suggested I try doing a still life before class: "Maybe a simple coffee cup, or a few pieces of fruit that you can paint from life," he wrote.

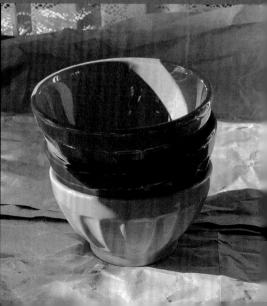

I bought some oil paint and some brushes and painted three paintings: a stack of three bowls, a single blue bowl, and a bowl of cherry tomatoes. They looked as if they were floating. The brush was an impossibly clumsy tool—not a rational way to apply pigment to a surface.

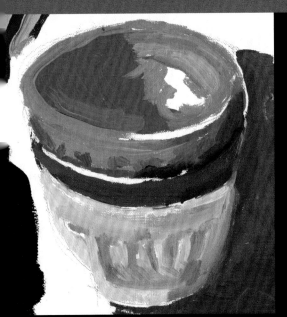

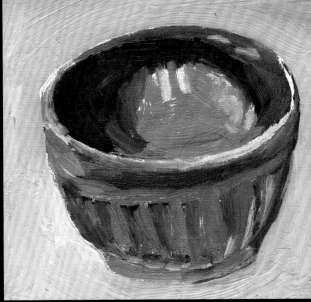

The next morning I went back to the art store and bought more paint, plus a pack of five sheets of Saral transfer paper. Transfer paper works like carbon paper, but it doesn't have wax, which can mess up a painting.

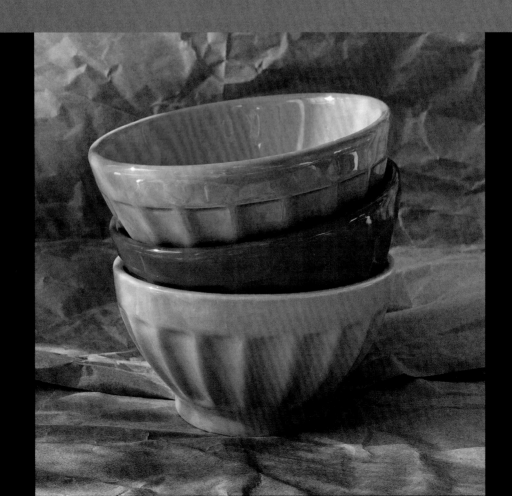

I printed out a photograph I liked of the stack of three bowls, and I taped it down over a rattly piece of red transfer paper, onto a fresh expanse of primed linen canvas. Bearing down hard with a pencil point, feeling bold but devious, I traced the oval rims of the bowls and the fluting on their sides, and I circled their highlights.

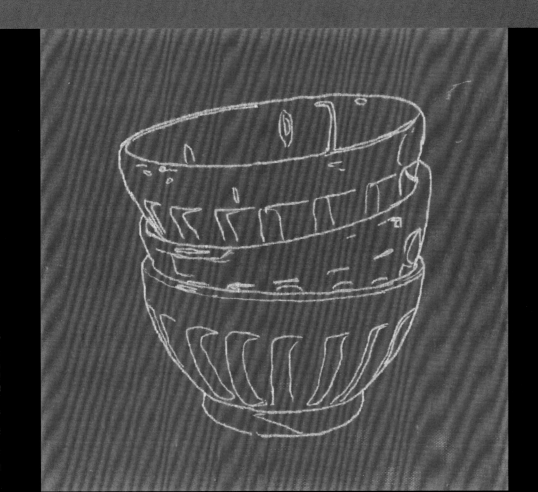

Then I spent an hour and a half painting the traced image. I matched the colors as closely as I could by dabbing experimental mixtures directly onto the photograph— something Mark Carder had suggested I do. The results were better than the day before.

What I learned:

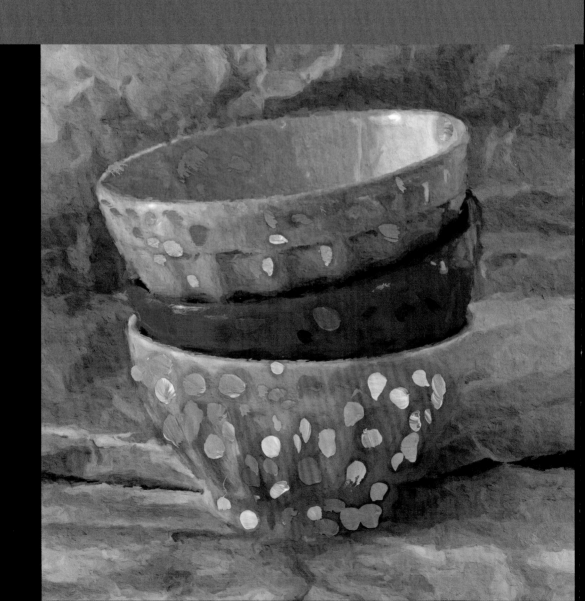

(1) Color is everything.

(2) But you have to get the shapes right.

(3) Shadows are shapes.

(4) Paint is smooth and it wants to blend.

(5) It's not going to dry for a long time.

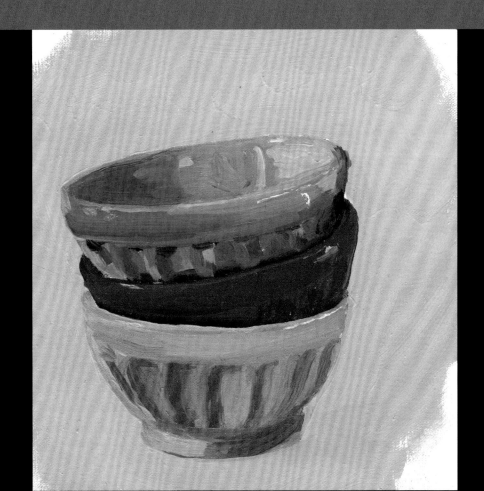

At the workshop on Monday we sat at picnic tables and introduced ourselves. Several students said how much they loved the idea of plein air, but even so, they did a lot of painting indoors, working from photographs. "My goal is to spark up my color," said one student. "I do work from photos, and they all are horrible. You can't see what's there. It's evident that painting from life is better."

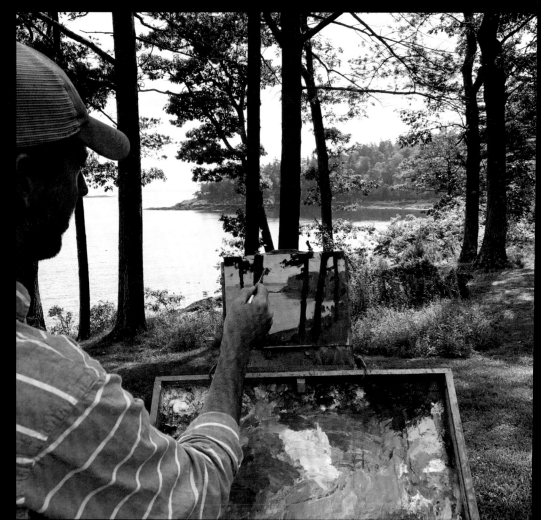

Colin explained how he set up his palette, with ultramarine positioned above phthalo blue, so that even in very bright sunlight or at twilight he knows which is which. He gave us some color theory and showed us paintings by Andrew Wyeth, John Singer Sargent, and Joaquín Sorolla.

Then he painted what we were looking at. I learned a new word: "skyholes." The color of the sky in a skyhole is often different, Colin said, than the color of the sky. His painting, which took maybe half an hour as he talked, was quite good.

After lunch we all went off in different directions. Each student had a chrome bucket dangling from her or his paint box. This held "turp"—either old-school turpentine or Turpenoid or Gamsol, some variety of OMS, odorless mineral spirits.

I set up on a little roadway that sloped past several tiny motel cottages, and I scrubbed a burnt umber undercoating on my surface, which was held to a board with a powerful clamp. My brushstrokes felt remarkably inept. Detail was impossible. Colin dropped by every so often to give me tips. He told me to lighten

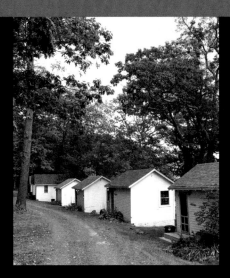

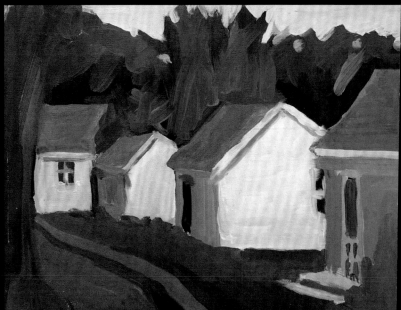

the green in the strip of grass in the middle of the road, and he showed me how to correct my perspective in a roofline, both of which helped.

I told him about my effort to paint the three bowls and confessed my use of a photograph—and then he told me an interesting thing about how he worked. He did a lot of painting outdoors by eye in the warm months, but in the winter, he painted big paintings in his studio, drawing on his banked fund of plein air knowledge while working from sketches and reference photos.

Colin Page, *Hillside*, 36 x 48 inches, i.e., big

The next day I drove to our rendezvous spot, a barn near Camden, with what felt like a new set of eyes. There was a vast mist that burned and murmured beyond the guardrail on Route 1. I pulled over, rolled the window down, and took pictures—and I vowed that someday, with the help of those pictures, I'd paint what I'd seen. In every direction, the world seemed freshly canvas-worthy.

Colin sketched a mountain of cloud and explained the inner life of shadows. He showed how colors, properly juxtaposed, could be made to vibrate. He quoted a teacher of his: "Open your damn eyes!"

I took a photo I liked of the students setting up outside, and I made a terrible painting of a door.

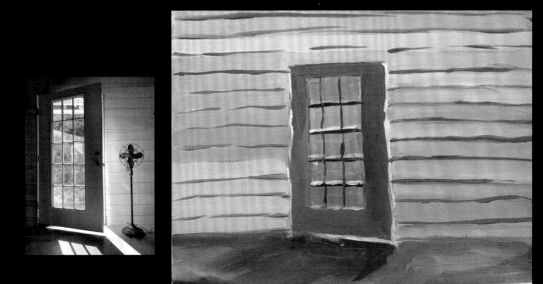

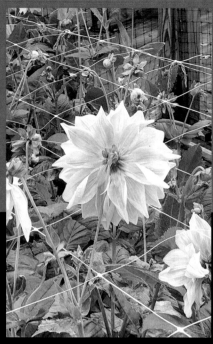

The day after that we were at a flower farm, where we had the opportunity to paint dahlias and birdhouses. I chose a pale yellowy-pink blossom that had way more petals than it knew what to do with. My yellows got muddy because in the barn the day before, by mistake, I'd put the cap from a tube of red paint on the tube of yellow paint and vice versa. Colin dropped by and he could see I was floundering. He made a sympathetic sound.

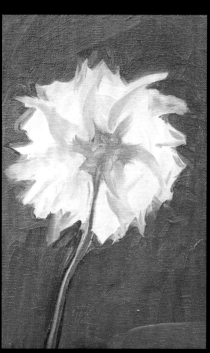

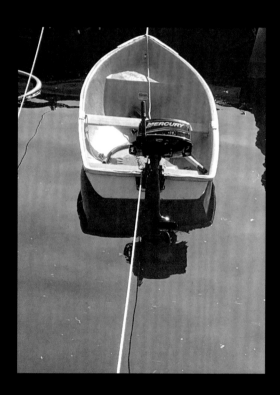

The last day I painted some of a blue boat. Not a good art day. But I loved the class—loved seeing how kind Colin was to the easeled aspirants, some of whom had a real knack. Loved how he patiently explained how to make the colors of boats and flowers pop.

I realized several things from my first efforts at painting. First, that the looseness and physical wobbliness of a brush caused problems and would take a lot of getting used to. Second, that I missed the precision and the erasability of a pencil. Third, that I really didn't know how to draw. I did not know how to use a pencil.

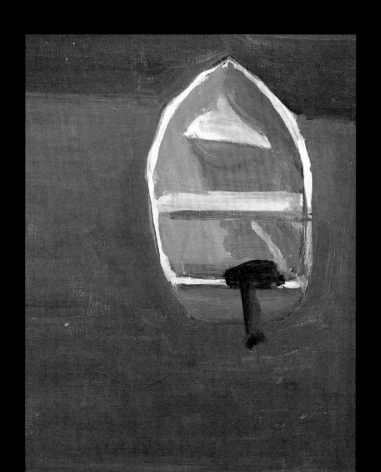

October 2019. After the Colin Page workshop I made two more oil sketches—two attempts to paint a jar of mineral spirits. Then I packed away all the tubes of oil paint for the time being. Oils took a very long time to dry—that was one problem. The paint was still wet the next day, and the next week, when you might want to add a layer of glaze, or touch up a mistake. And if you wanted to speed up the drying, you had to use a medium like Liquin, which isn't as noxious as turpentine but can reportedly cause chest pains. Since my heart has been unmannerly recently, I decided to put away the solvents. This was on October 1, 2019.

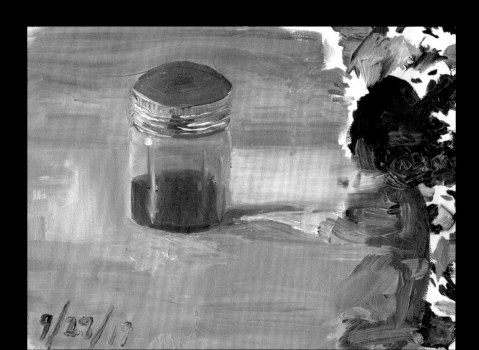

The next morning, at six a.m., I took a photo of our side door, thinking, This is exactly the kind of thing I'd like to be able to paint. But then, instead, I found a pencil and a piece of toothy paper, and I drew the door from the photograph as displayed on my iPhone, propped up against a book. No tracing, just sketching. I was startled by how easy it was to hold a pencil after wrestling with a glop-tipped eraserless mop-flopping palette-puttering art wand. And how absorbing and calming it was. The physics of the two implements were entirely different, I suddenly realized: the pencil was controlled

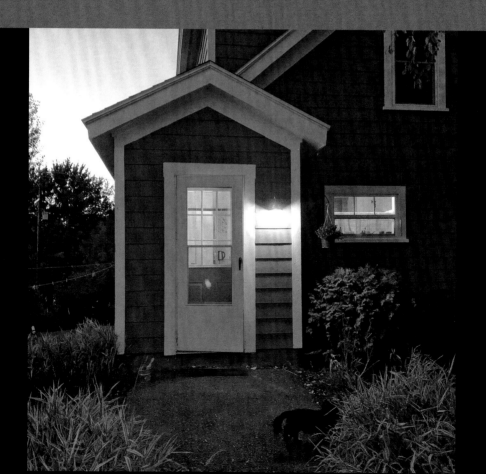

by small meticulous muscles of the hand, very near its business end, whereas the brush was subject to the whims of arm and shoulder, and was held like a cigarette holder, far away from the burning nub of creation.

It's not much of a drawing, but when I re-created the notched edge of the roofline it felt huge.

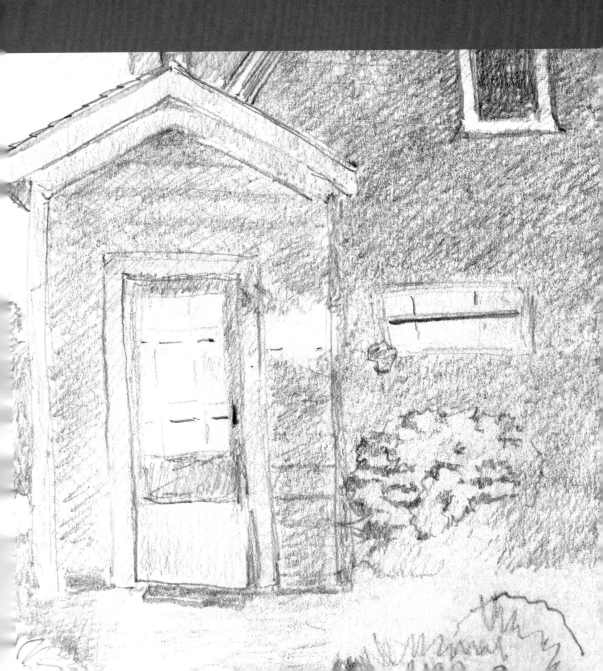

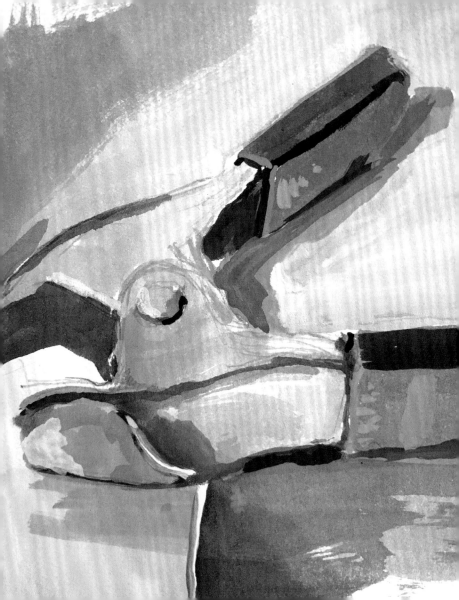

I wanted to keep going with painting, though, while avoiding the fumes. It would not be good to just give up. M. suggested I try gouache paint, which is a kind of thicker, opaque watercolor. I bought some tubes of it at the art store and painted an easel clamp, a green leaf with yellow veins, and a dried vine with water droplets. Gouache was easier to handle than oils. It dried fast and smooth, with a matte surface: in the golden age of magazine illustration, art directors liked it because it photographed well, much better than shiny oil paint.

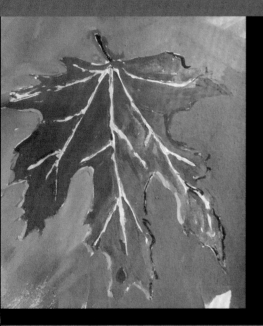

James Gurney, best known as a painter of dinosaurs, was my guide through the world of gouache. I found him on YouTube and read some of his blog, *Gurney Journey*. Then I bought an instructional movie by him for $14.95 called *Gouache in the Wild*. In the movie he paints a series of subjects, the first of which is a liquor store sign in Salida, Colorado. He's got a gentle voice and a sensitive eye, and there's a thrilling sort of methodical eagerness to his representationalism, which he pursues while squinting at the Colorado sky, seated on a stool on the sidewalk amid pedestrians.

In another chapter of the movie, Gurney, waiting for a mechanic to install a

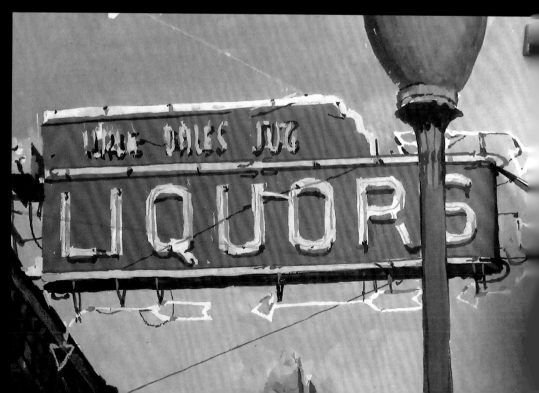

new tire on his car, paints a Citgo convenience store—paints it faithfully and with affection. "A lot of times, my favorite paintings are the ones I do where I'm stuck somewhere, at a laundromat, or a hotel, or a car fixit place," he says. Gurney's dinotopias are great, but he's also a magician of normalcy, of familiar, sun-bleached, unremarkable American life. One of my favorite of his sketches can be seen in a YouTube video called "How to Start a Watercolor." He and his wife and some friends paint a sunlit lawn chair together. "Sometimes minutes or hours can go by without a word spoken, while we stay in our deep concentration," he says.

I asked myself, What do you really want to paint? The answer was: clouds. Clouds and, of course, trees, because trees are terrestrial clouds. Maxfield Parrish's heaped, beehive-hairdo clouds fill me with shuddering, bulbous joy. On Pinterest I looked at a dozen of Parrish's paintings, and I read about how he painted from photographs, projecting images onto the canvas in order to trace them, using a handmade optical device, forerunner of the Bausch and Lomb Balopticon, loved and hated by American illustrators.

I searched Pinterest for more cloud painters, and I found a Canadian wizard named Renato Muccillo. He began as a wildlife painter, and then moved to boundless Netherlandish skyscapes. Muccillo is able to create heart-seizing fluffmonster clouds seemingly at will, and also he offers weighty studies such as *Laden Skies*, below right, which sold in 2019 for $19,700.

In an unused parking lot near a Home Depot, I took an iPhone photo of ripped, backlit clouds flung out beyond a red For Lease sign. I drove home, excited, and made a rough pencil sketch. Over it I tried to paint some of what I liked in the photo onto the page. I was disgusted by the result and left it unfinished.

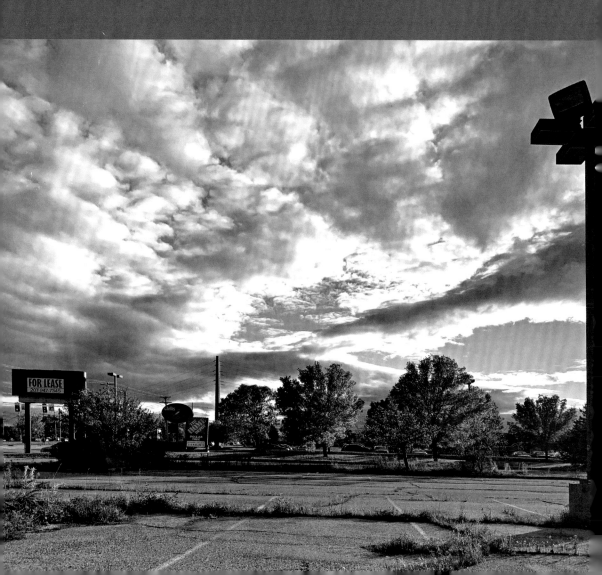

The next morning, nonetheless, I woke up consumed by the idea of painting clouds—puffy, huge, lunglike, breathing, hippopotami of the sky.

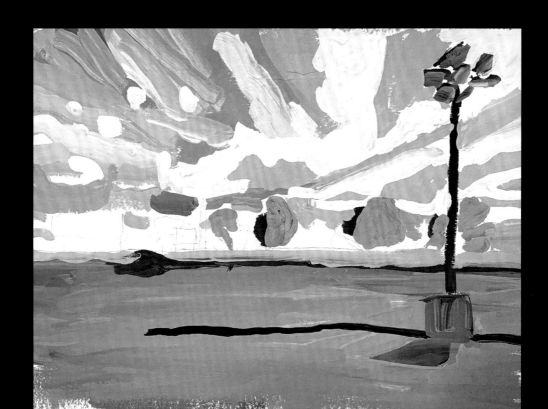

Late in the morning, I found some good clouds near a Chipotle restaurant, photographed them, and tried to paint them. Again a disappointment—the car came out looking like a pool table—but at least I finished the painting. An odd thing about gouache: it changes color when it dries.

In the afternoon, M. and her friend Minette brought home a squash from the farmers market and suggested I paint it by eye. Now the pressure was on.

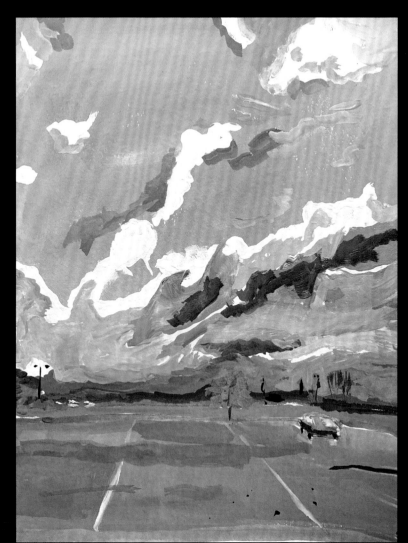

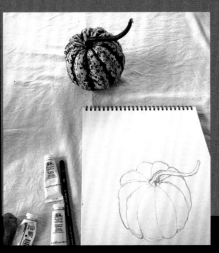

The pencil sketch went all right, and the squash had an interesting pixelated pattern, which I got to know well by the end of an hour and a half. By then the dots and dashes seemed like some sort of botanical code.

The great thing about painting a squash is that the colors are simple and well-defined, and you can eyeball it and get the pattern wrong in places and nobody will notice: it still looks like a squash.

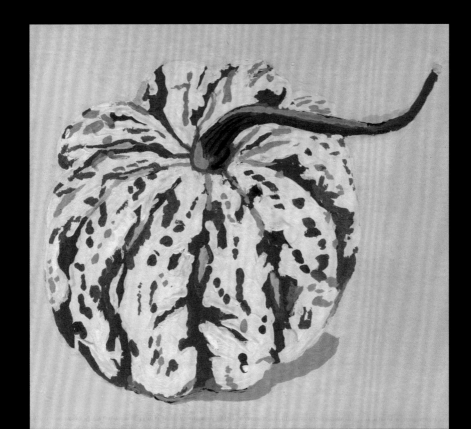

The next day I saw a dried maple leaf on the lawn, brought it onto the porch, and made a pencil drawing of it. Once again, as I drew, I felt the feeling I was hoping for—the feeling of wholly engrossed concentration. My pencil-pointed mind swooped and swerved in and around the sinuses of the leaf, then paused to feel how strangely sharp the lobe-tips were. Each turn I took on paper taught me what the next leafy turn had to be, as my eye shuttled back and forth between object and echo.

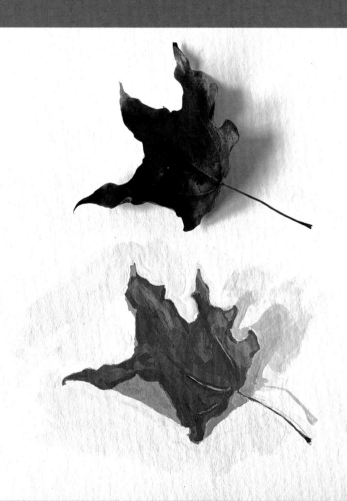

When I moved on to painting, I tested out the red-browns I'd mixed on the edge of the paper. I used a smaller brush than I'd been using, and I was glad to be able to include the pale curved shadow of the stem—it lingered there in the painting even though the sun had moved by the time I took the photograph.

At some point I came to the end of my first tube of gouache paint. Titanium white was the color I'd used more than any other. That was some kind of milestone.

Near the Chipotle was a multiplex movie theater—a drab building with the huge red word CINEMAS affixed to it, and a red sapling in the parking lot. I painted it once by eye but flubbed the parked car and other things. (Cars are hard.)

I lost my temper at one point and typed, "I HATE THIS TOAD OF SHIT THAT HAS EMERGED FROM MY BRUSH."

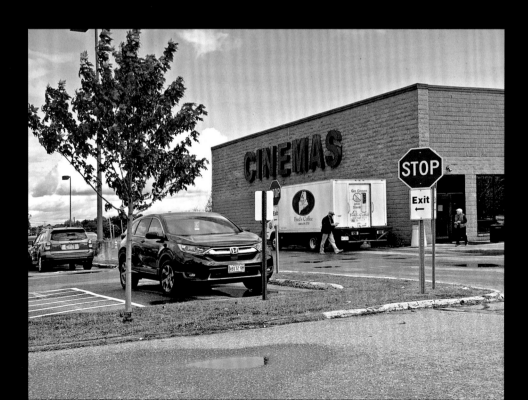

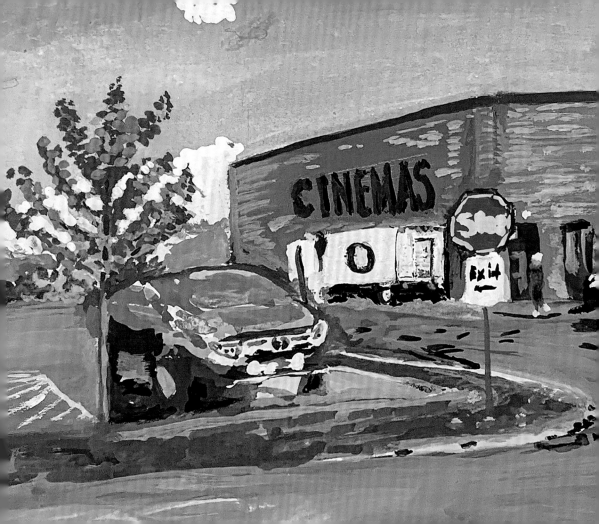

So then I doubled down. In Photoshop I eyedroppered and color-replaced colors in the original photograph five or six times, while leaving the tree and the sky alone, so that the building and the parking lot, with its post-rainstorm puddle, took on a sequined, pointillistic, silver-screen sparkle. Then I did my best to match with physical dabs of gouache the dotted surface patterns that I'd made using software.

For this painting, I switched from traditional Winsor & Newton gouache to Turner acrylic gouache from Japan, which handles like regular gouache and has a

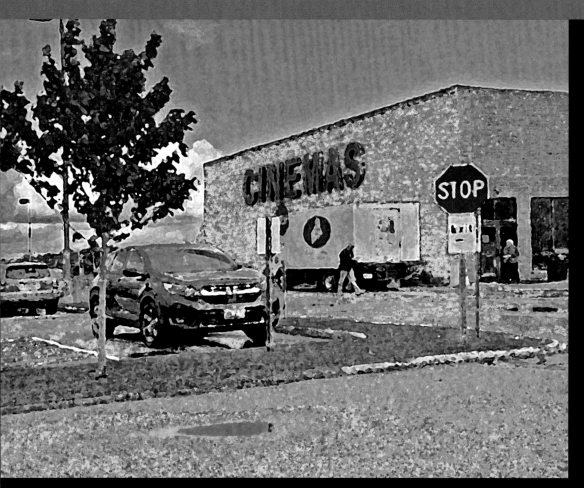

Hypercolored source photograph after several cycles of Photoshop adjustments

matte finish but doesn't change color so dramatically when it dries. After two days of dotting and dabbing and muttering over the (traced) image, I was done. The result was . . . not Klimt, not Vuillard. Not beautiful. But candified—as if the boxes of Skittles and M&M's and Sour Patch Kids in the concession stand in the movie theater had escaped and had barnacled over the brutalism of the outside world.

The side benefit was I learned a good deal about mixing and matching color.

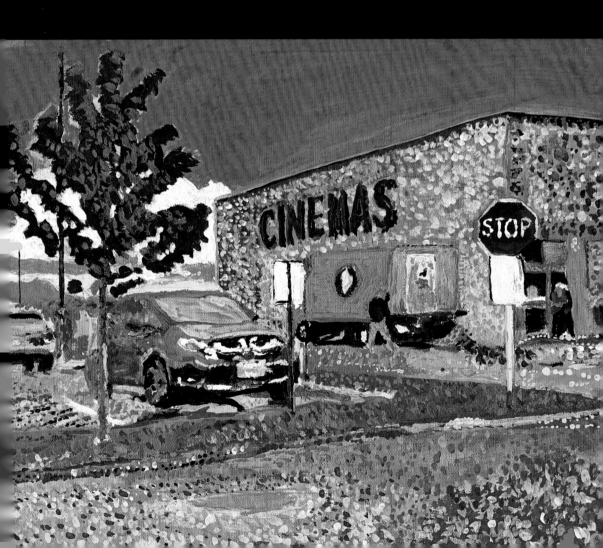

I began drawing faces in close-up, freehand, with the hope that if I could get better at doing faces, which required exactitude to achieve a resemblance, everything else would follow. My first drawing was of a woman on the phone, copied from a gouache painting by Gwen Fremlin (1921–2001) for a November 1948 short story in *McCall's* magazine. (Pinterest led me to her.) Fremlin, who lived in Toronto, made a very good living—$45,000 a year in 1951, or more than $400K in current dollars—as a freelance illustrator.

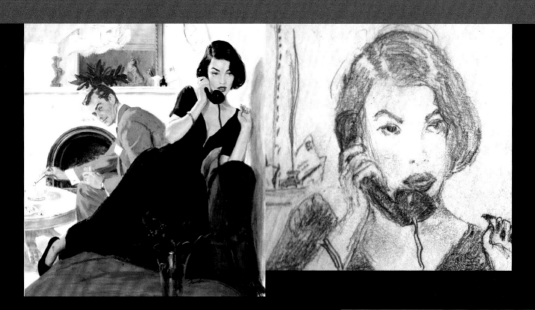

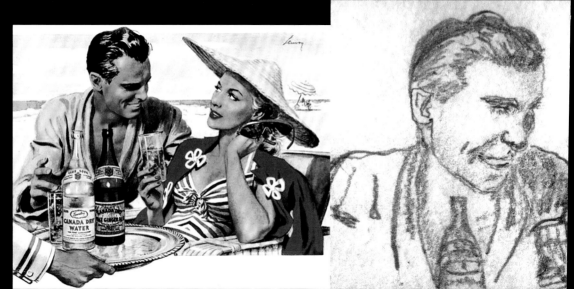

I also copied a couple from a Canada Dry ad painted by Robert Levering, who was a star of advertising illustration in the fifties and sixties. Levering furnished the art for a flamboyant fat-shaming series of ads for Pepsi-Cola, including "Refreshes Without Filling" and "Fashion is for the Slender."

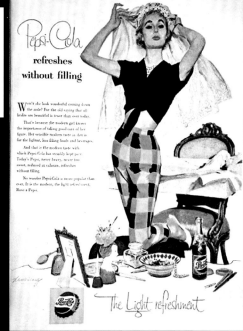

Pruett Carter's short story illustrations held my eye, including *Through the Window*, which looked a bit easier to copy in gouache because it was printed in only two colors, yellow and black. Instead of tracing, I used the grid method to transfer the outline, and I painted the woman in profile and the curtain next to her. Then, reading more about Carter's life, I stopped, shocked.

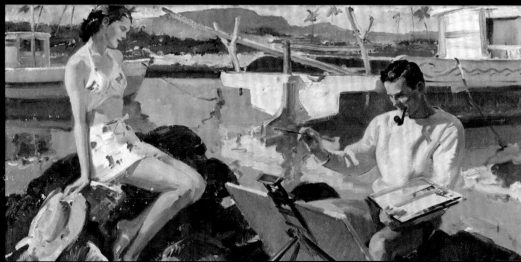

Pruett Carter (1891–1955) was vastly successful in the magazine world, I learned, but after the illustration business collapsed in the fifties, he lost his mind and shot his wife, his disabled son (a freelance television writer), and himself in his house in Studio City, California. He was found slumped near his son's bed, wearing blue pajamas, a gun in his hand.

Moral: A lifetime of painting will not necessarily keep you from becoming a monster.

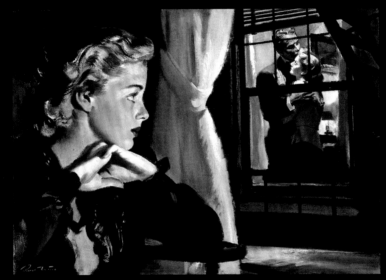

Pruett Carter,
Through the Window

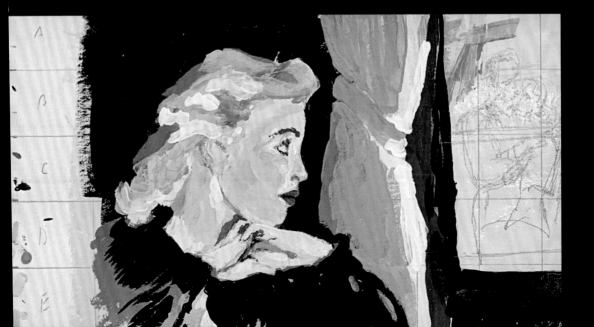

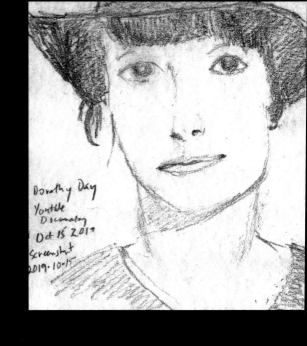

Dorothy Day
Youtube
Documentary
Oct 15 2019
Screenshot
2019·10·15

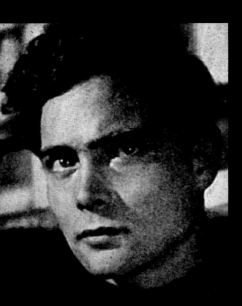

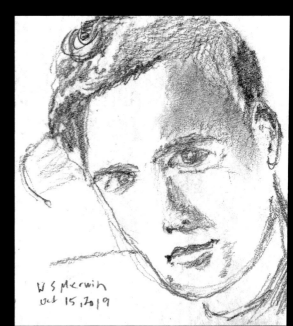

W S Merwin
Oct 15, 2019

I started to feel that I wanted to spend the rest of my life doing portraits—that in fact I wanted to draw every person in the world. On October 16, 2019, I did six drawings, including one of Dorothy Day, one of poet W. S. Merwin from an early photo, and one of my wife.

 In my journal, I wrote, "There are moments when I'm drawing where I feel a sort of vibration of newfound proficiency in the tiny directional decisions that my hand makes. It's starting to know what to do. I feel strange little rushes of almost confidence."

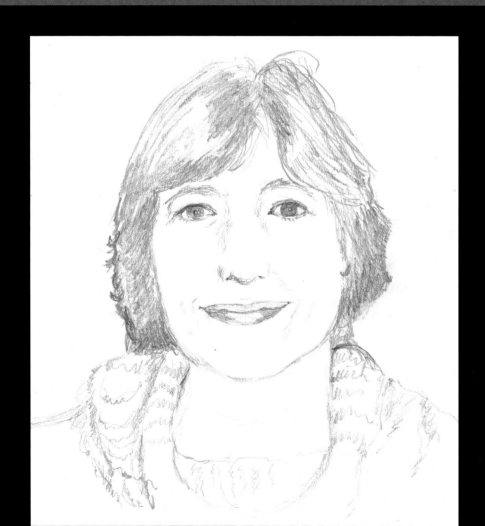

Weeks went by, though, when almost all the faces turned out badly, sometimes quite horribly. My drawing of Mark Twain, from an 1867 photograph taken in Turkey, did kind of look like Mark Twain, but his eyes were crossed.

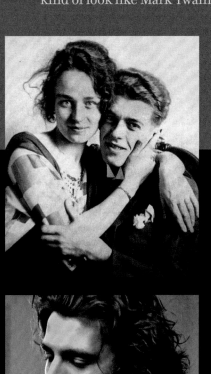

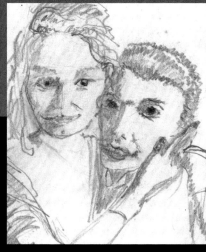

René Magritte
and Georgette
Berger

Yon González

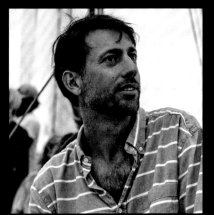

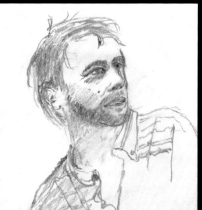

Colin Page

I found that I really liked drawing hair. You didn't have to get hair exactly right to get it right.

Photograph of a model
by Dmitry Ageev

Chloe Blanchard
on Pinterest

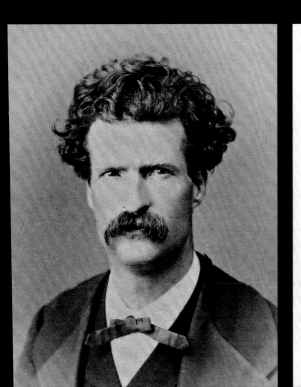

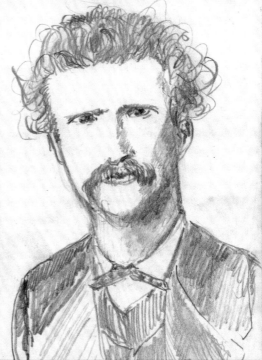

I knew I should be painting every day, but then every day, at the moment of decision, I reached for a pencil instead of a brush. Meanwhile Pinterest kept offering me interesting artworks to copy: one by Elana Hagler, for instance, who was born in Tel Aviv. One by Heinrich Vogeler, who was sent to a mental hospital after he wrote an open letter to the kaiser appealing for peace, and one of a woman in a tall chair by Katya Gridneva from London. The freehand drawing I did, primitive though it was, got me to

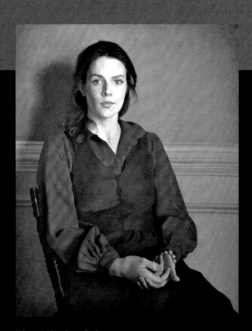

Elana Hagler, *Debra*

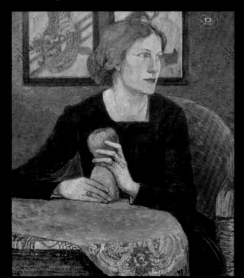

look closely at the source image and find out why it worked. I learned about the ulnar grace of forearms and the segmented drape of fingers, and how weirdly long the middle finger is. Each sketch left me with a tiny residue of heightened figural knowledge. Just looking wasn't enough. You had to be drawing while looking for the forms to flow in and feed your sense of sight.

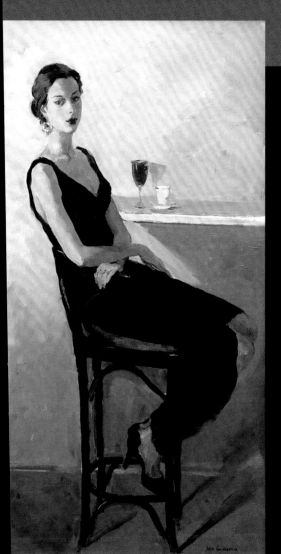

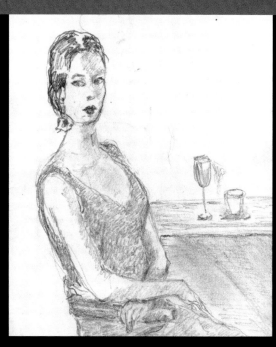

Late in October, idly browsing Instagram for inspiration, I discovered a post by a talented and successful illustrator who announced that she was going to reveal her secret drawing method. In a dark room, this artist said, she tapes a piece of blank paper to her laptop screen and traces over the digital image beneath. Everyone does it, she added, but not everyone mentions it. In her opinion it was nothing to be ashamed of.

A detonation went off in my brain. No need for tracing paper or transfer paper. No need for a light box. Just tape a 9-by-12 sheet of drawing paper directly to the computer screen and trace what's there and off you go. So beautifully simple—and also oddly reminiscent of

Albrecht Dürer's method of tracing candlelit portraits on a translucent sheet of glass while looking through an eyepiece. "Draw whatever you wish to paint on the pane of glass," Dürer wrote. "This is very suitable for portraiture—especially for those painters who are not sure of themselves."

Soon, though, the illustrator deleted her Instagram post; she explained in an email that she was embarrassed at having suggested the screen-trace method, and said that she no longer advised beginning a drawing that way, or only occasionally. A number of other artists and illustrators have, however, publicly endorsed the practice—including a smart, fast-talking YouTube artist and teacher named Lisa Lachri, who draws and paints cheetahs and tigers and

undersea creatures. Lachri said she's been tracing on computer screens for years, and she showed how to tape a sheet of paper over a photo she'd taken of a giraffe with its tongue in its nose. "This makes me feel so much better," said a commenter. "I've used my monitor like this for a long time, but never wanted anyone to know because I felt guilty about tracing."

So I was tempted to trace faces, extremely tempted. I heard the ringwraith music several times. But I stayed strong, because I believed that I needed to "train my eye" by drawing freehand. Tracing was a crutch—that's what many people thought. Some of them

Fipsi Seilern, *Syrianna*

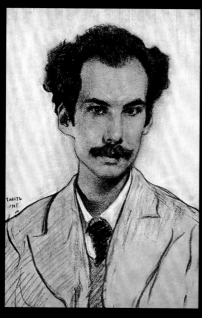

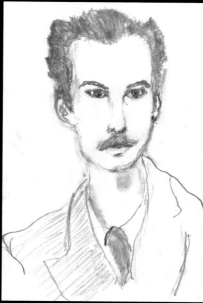

Leon Bakst, *Portrait of Andrei*

Self-portrait by Sander Weeteling on Unsplash

were quite fierce about it. Tracing was evil and wrong. It was cheating—a confession of weakness. Tracing would hold you back, keep you from developing a heightened sensitivity to curves and shapes and proportions.

So I kept at it, eyeballing every sketch, forcing myself to estimate cheekbone angles and nostril-wing distances, making drawings that were obviously wrong in the most fundamental way: they didn't look like the person they were supposed to look like. Trawling Pinterest and Unsplash (a royalty-free stock photo website) for faces, I gradually got better at smudging in shadows with my finger, and at erasing to make a highlight or a shiny strand of hair. But the result was always off—always a miss, not a match.

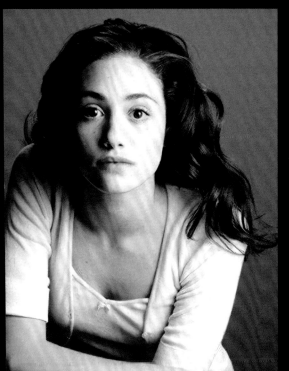
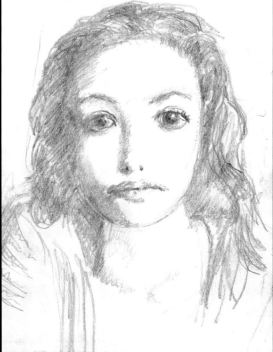

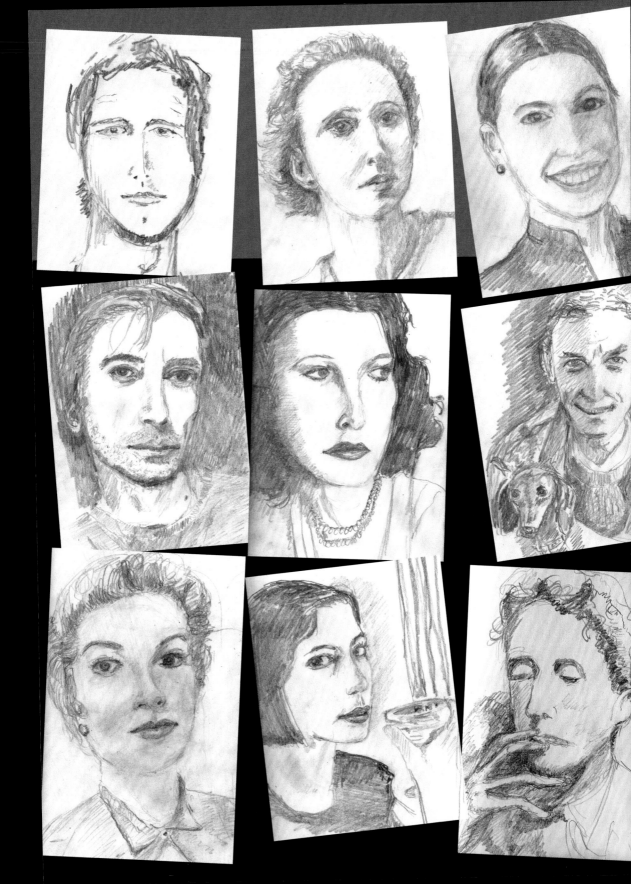

November 2019. Maybe doing more famous, familiar faces would sharpen my instincts? Sure, I'll try. I sketched Chevy Chase, Kate Beckinsale, E. B. White, Anaïs Nin, Javier Bardem, Alexandria Ocasio-Cortez, Hedy Lamarr, and Lana Turner. I took off my glasses to draw Jean Cocteau smoking a cigarette, to see if that helped me see shapes better. I also drew my wife again, working by candlelight at the kitchen table at six in the morning.

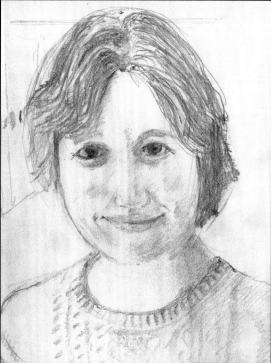

I didn't want to lose touch with color altogether, so I got out the gouache tubes once a week or so. Using paper plates as palettes, I painted copies of works by Leo Putz (1869–1940), whose art was labeled degenerate by the Nazis. Putz had a tender, hospitable way with windblown light. He painted many naked bathing beauties, but he was good with people wearing clothes too.

I don't know anything about Rudolf Tewes (1879–1965), but I liked his big hat

Leo Putz

John Singer Sargent, portrait of Robert Brough

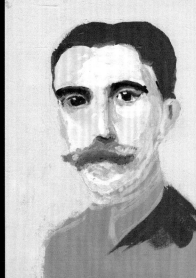

and his hands in his pockets, and the mottled surfaces of his blue outfit and the wall behind. Sargent's handsome friend Robert Brough (1872–1905) was a skilled Scots portraitist who died young of burns suffered in a railway accident. And Albert Marquet (1857–1947), a reformed Fauvist, painted an affectionate portrait of his wife, Marcelle, against a checkered background in 1931. I have no idea why I changed the background color to blue.

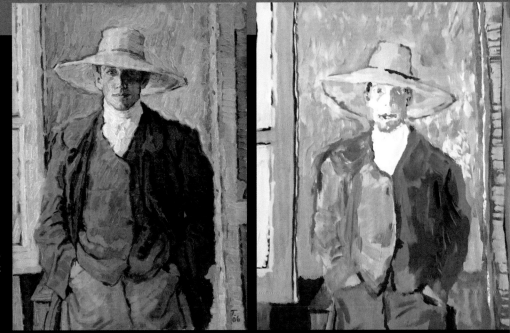

Rudolf Tewes,
self-portrait

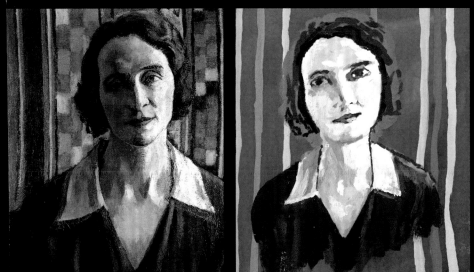

Albert Marquet,
portrait of
Madame Marquet

What I was trying to do, I guess, with each little burst of painting, was to get more fluent. Draw with the brush and not the pencil. Accept the clumsiness and imprecision and learn to make it work for you.

It wasn't working for me, though. Pencil drawing pulls you in and gives you a thousand delightful minuscule problems to solve. Everything happens on the

page, in the self-contained world of graphite granules, whereas half of painting happens offscreen, on the palette. Unless you use the page as the palette, as I did sometimes.

The mixing of colors, until and unless it becomes second nature, is a distraction and a joy killer.

I bought a pad of thick gray mixed-media paper—too thick and dark to even think of tracing through—and a white pencil for highlights, and I used the proportional divider that I'd ordered from Mark Carder to make what I hoped would be more accurate drawings. This measuring mechanism, used during the Renaissance, can do fancy things like scale up or scale down a drawing, but it's also useful if you're trying to steer clear of tracing. It offers a quick way of transferring dimensions in your source photograph to your drawing. For instance, I measured from one pupil to the other in a photograph of a model by Maarten Schröder, and I made two little white dots where the eyes' highlights (or "catchlights," as they're sometimes called) would go. I measured the length of noses, and the distance

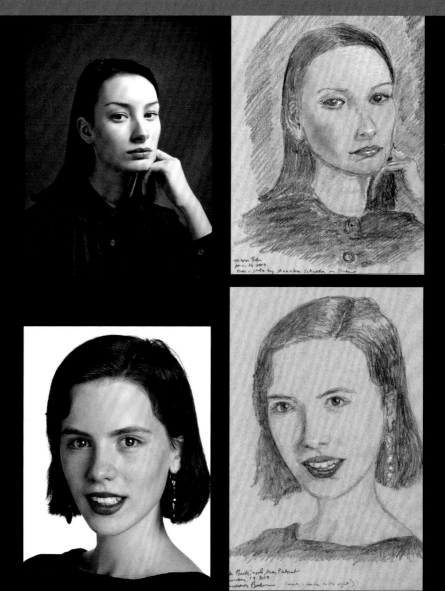

between corners of mouths—measured and measured. But very often, even so, I would get a crucial angle slightly wrong, and that error would then propagate itself and distort the whole face. A mistake in the angle of a cheek, for instance, might throw off the placement of a mouth, as in my drawing of Kate Beckinsale.

The third drawing is after a portrait of Vsevolod Garshin, a writer, by Ilya Repin, a Russian realist of renown who also painted several portraits of the aged Leo Tolstoy. (Also some spectacular crowd scenes.) Repin catches Garshin's sadness: Garshin wrote a story about bad times in a psychiatric hospital; at the age of thirty-three he flung himself down a set of stairs and died of his injuries.

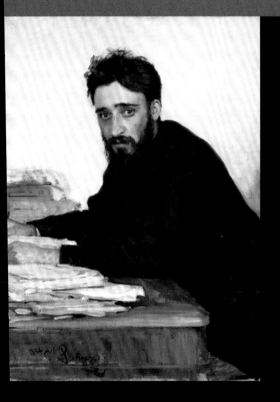

I began a series of drawings of people I admire. I drew Denise Levertov, poet. Helen Caldicott, antinuclear activist. Robert Macfarlane, nature writer. Medea Benjamin, of CODEPINK. Tom Engelhardt, editor of TomDispatch, and (again) Alexandria Ocasio-Cortez. The drawing of Levertov is the best one, I think. There was a stiffness about all these drawings. Maybe it had to do with how dependent I was by then on the proportional divider.

There was a grayness, too, that had something to do with the color of the paper.

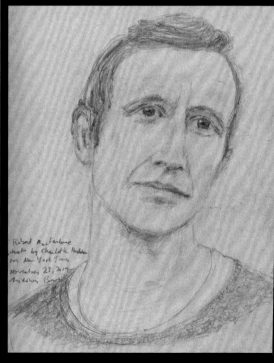

M. and I drove to the Colby College Museum of Art in Waterville, Maine, and I took a picture of her in an orange sweater as she looked at some Japanese pottery in a hallway near the big Robert Henri painting of a Spanish dancer. I felt a great happiness to puzzle over ancient artifacts and belle époque paintings with her. The photo I took went into an album called "To Paint."

Robert Henri taught Edward Hopper and others at the Art Students League, and his book *The Art Spirit*, a collection of his thoughts assembled by one of his students, is full of little nuggets. For instance: "All real works of art look as though they were done in joy." And: "Those who cannot begin do not finish."

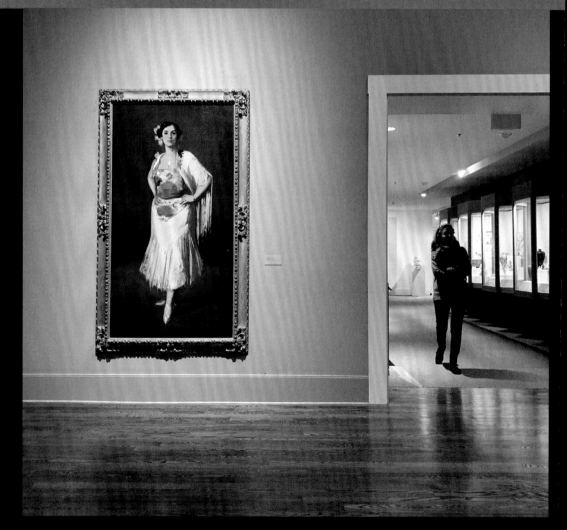

Henri was very taken with the Spanish woman in his Colby Museum painting. Her name was Milagros Moreno, and she was, he wrote, very kind in her dealings with people, but almost savage when she danced, "with a fierceness that is terrible." This was in 1906. Moreno sat for him a number of times while he painted her, and then she canceled future appointments.

I like Henri's loungey portrait of Gertrude Vanderbilt Whitney—who made monumental sculptures and founded the Whitney Museum—and I like his painting of a woman in a beach hat.

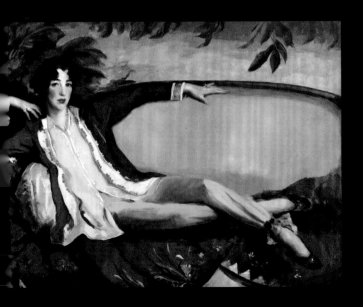

The day after Thanksgiving I drew Dorothy Day again. It was a privilege to be tracing the outline of her cheekbone, feeling the strength of it, knowing how many days and years she spent writing editorials against wars. Also feeding and housing the homeless, the insane, and the drunk.

The line came down from her cheekbone almost vertically, and it flared slightly at the jaw. Then it turned inward toward her chin, which had a strong noticeable cleft.

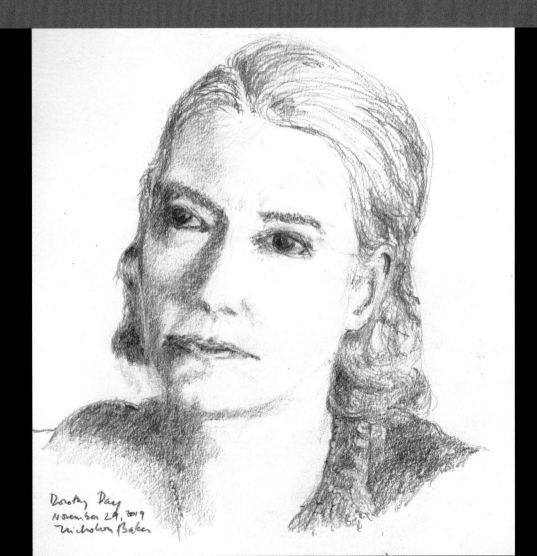

Dorothy Day
November 29, 2019
Nicholson Baker

December 2019. I flew to New York City to take Karen O'Neil's two-day workshop at the Art Students League, "Still-Life: Light and Color," which cost $293. I was recovering from some kind of eye malady—perhaps brought on by rubbing my eye too vigorously as I measured and drew faces in the early morning—so I was on a regimen of eyedrops and had monocular vision. The evening

before the class, I waited in line to pay $25 to get in to the exceedingly crowded Museum of Modern Art, which smelled of wet wool and umbrellas. There were some good paintings and some less good ones, by which I mean there were some soul-shreddingly bad ones. I have vowed, however, not to say negative things about specific overrated monstrosities of the art world. Klimt's painting of a pregnant woman and a skull was worrying but beautiful. What I liked most was watching people walk around in front of big paintings.

The next day, when we dozen students arrived at the still-life workshop, Karen O'Neil told us not to worry about painting a great painting. "People put a lot of pressure on themselves," she said. "Let's take that and just throw it out the window." Her goal for us was to teach us as much as possible about technique and color in two days. "If you understand how colors overlap and connect, think of all the wonderful things you can do with that skill." She painted a black cup on a black saucer resting on a black piece of paper—demonstrating how many subtleties of black there were. Then she asked us to

choose one of the still-life arrangements waiting on long tables for us to paint, each lit by a clamp-on light. Using gouache, I painted a melon, two cherries, and a green apple. And I took a picture of the sink, because I'm drawn to sinks.

One of the students worked in pastels, which looked interestingly scratchy.

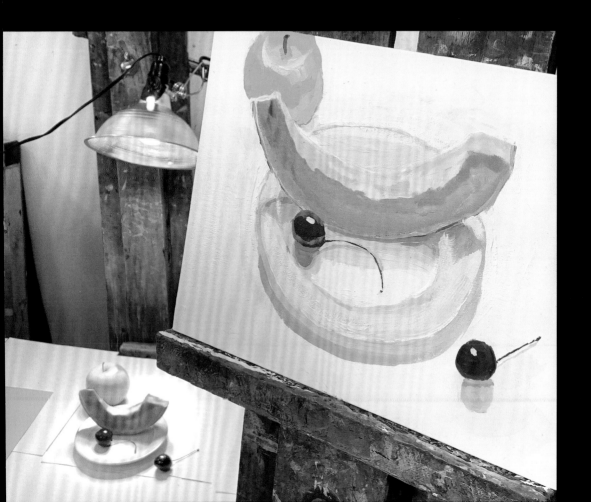

The second day of class was devoted to the painting of glassware. My assignment was to paint a lime, a wedge of orange, and a green-tinted glass. Karen suggested that I darken the shadow in the base of the glass, and I did and it was better.

She said, "There are always six or seven things that will work when you're painting. So don't worry that there's one right way and you didn't find it. There's lots of right ways."

She told me she'd studied with George Nick at the Massachusetts College of Art, and she'd learned color theory from Henry Hensche at the Cape Cod School of Art in Provincetown.

She also said, "You only need one glove."

Henry Hensche,
Ada in Sunlight

I drove home from the airport in the snow and went back to drawing faces. Susan Sontag I drew three times, the last time without resorting to the proportional divider. She looked a bit like Mary Tyler Moore in my renditions. I also drew Robert Louis Stevenson and Dorothy Parker.

I drew writer Maeve Brennan looking in a shop
window (from a crop of a lovely photo in *Life*
magazine by Nina Leen), and *New Yorker* editor
Katharine White. White I drew three times, and
the third time felt like a minor breakthrough.
I'd gotten her nose almost right.

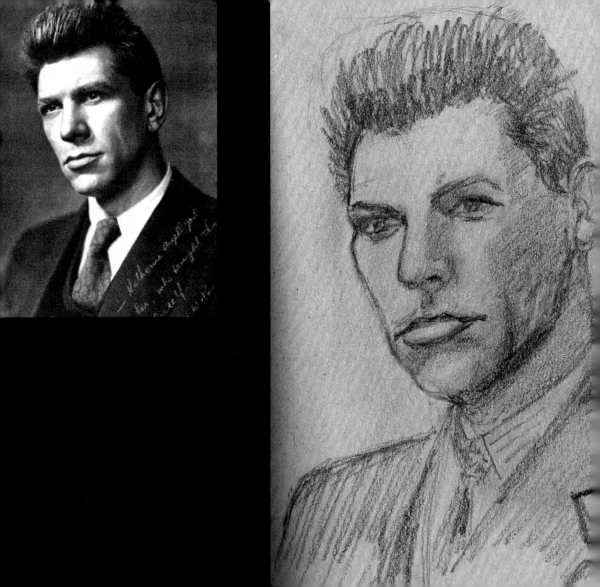

Next I got the urge to draw the founding editor of *The New Yorker*, Harold Ross. I thought he might be easy because he has such strong features, and such a flume of hair.

I tried twice and stopped. I'd made him look like a boxing promoter.

Early Middle

2020

On January 7, 2020, my sixty-third birthday, I found a new artist on Pinterest: Masayasu Uchida. He was born in 1922, and he made mountains and clouds out of torn rice paper. He died on September 12, 2019, at the age of ninety-seven.

I found some astonishing woodblock prints by Gordon Mortensen (born 1938), and some paintings of empty places by Jim Holland, of Cape Cod.

Life has all kinds of possibilities.

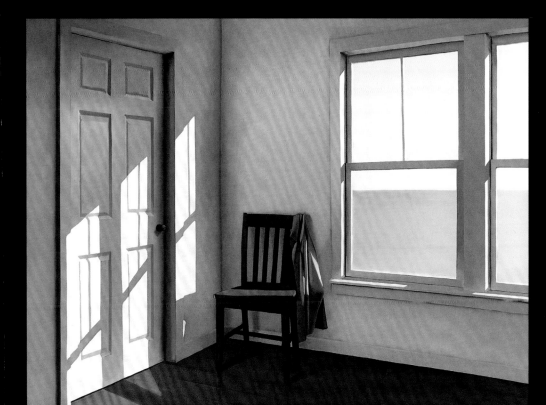

A kind of big moment—a huge moment—of decision came on January 9, 2020. After two fumbled attempts to draw Vladimir Nabokov in a rowboat in Cambridge (the first of which looked more like Martin Amis), I decided I had to get serious and trace. I turned off the lights, taped a piece of paper to the computer screen, and outlined

what I saw in the photograph, while containment-breach buzzers went off in my head. (The photo appears in *Speak, Memory*, Nabokov's memoir.) It took only a few minutes. I now knew just where to work: I wasn't worrying constantly whether a nostril or an eye was out of place. And an hour later, when I was done, sitting on a page of my notebook was Vladimir Nabokov himself, as a young man—his strong nose, his amused, perhaps kindly, but also perhaps arrogant gaze, his aristocratic forehead, and his cigarette (which I hadn't noticed before). I added catchlights to his eyes, and as a result Nabokov seemed even more present and alive and real than in the photograph. All because I began by tracing.

On January 11, 2020, I drew my friend James Marcus, a writer, former editor of *Harper's*. I'd tried earlier to draw him and it hadn't worked. He'd come out looking stretched, a little like Beavis in *Beavis and Butt-Head*. Now he looked recognizably how he looked. (The hand was still wrong, though.)

If I pressed hard as I traced, the MacBook's screen would emit a firefly flare of bluish light. And when I turned the desk light back on, there was the empty face,

like an architectural plan, waiting to be made into something fleshy and human—one person out of billions. This process of enfleshment, which sometimes took hours, was much more enjoyable than it had been, more relaxed, more fanatically attentive when I needed it to be—because when I removed the paper from the screen and started really working on the drawing, I knew I could trust the basic layout.

The next day I drew Frances Crowe, a war resister who died in August 2019, at the age of one hundred. The result looked like her!

Now, when I wanted to begin a portrait, I pulled the shades. I was a tracer of screens, and it was exhilarating, because my drawing got better. Almost every day, it seemed, my drawing improved a tiny bit, guided by the shadowy anchovies of subtlety and shadow that swam their way up through the paper

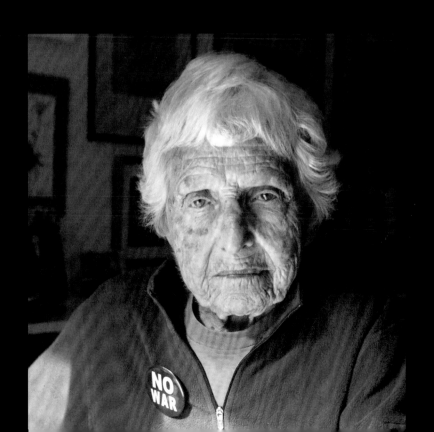

immediately under my pencil. When I made a mistake, and erased, and blew the crumbs away, I cackled: I could see exactly where I'd overshot and where I should resume. *So that's how it goes,* I would whisper. *Down here, along here, and then it dips in for a moment.* Yes, absolutely, tracing was a crutch. I needed this crutch. I wanted to walk down the path of portraiture, and this crutch was aiding me. A lot. Why fight it?

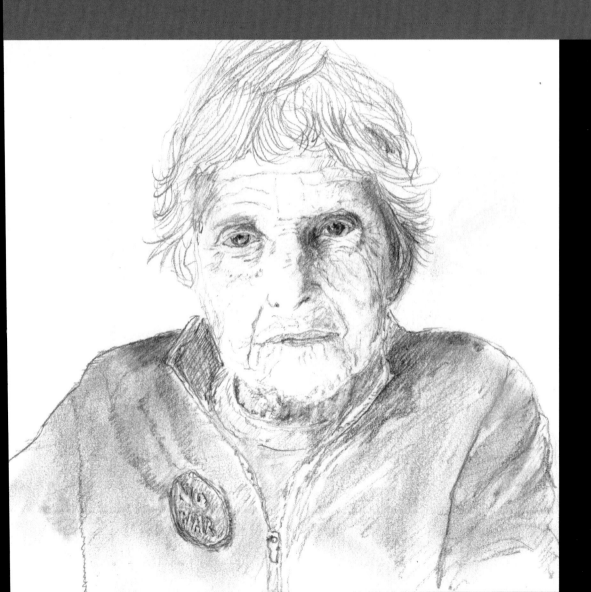

Could I now do an ethereal Pre-Raphaelite woman? Well, almost. I copied a drawing by a Victorian painter named Frank Dicksee. Also I copied an exquisitely simple work from 1892 by John Briggs Potter. Potter, whose style was influenced by Hans Holbein the Younger, became keeper of paintings at the Boston Museum of Fine Arts.

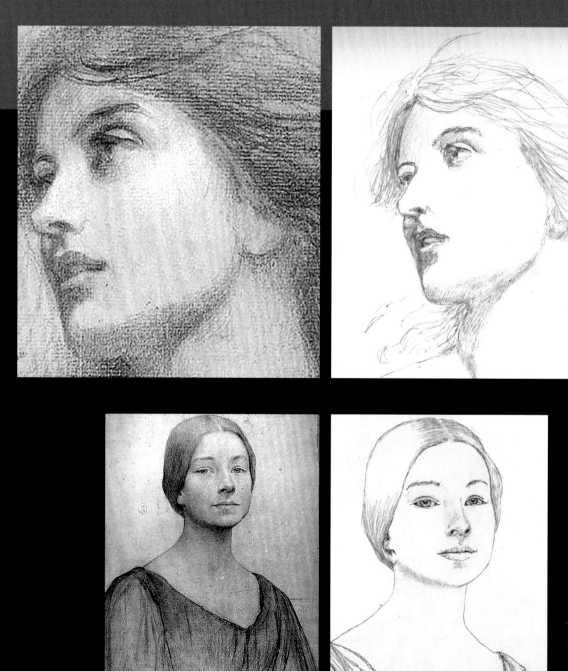

Below are two more of Potter's spare emanations: a pencil portrait of an unnamed man, and a portrait of Grace Ellery Channing, both drawn in Italy in the 1890s. Look at the life in her eyes.

Potter died in 1949. His eulogist wrote: "He was peculiarly part of a past which is irrevocably gone, and his death is the ultimate period closing a chapter of Museum history long since ended."

Because I was clicking on work by Frank Dicksee and John Briggs Potter, Pinterest felt I might like to see paintings by someone named John William Godward, a popular Victorian painter of women in filmy classical outfits on marble balustrades. Pinterest was right: the faces of Godward's models (one of whom he lived with in Italy) have a vulnerable grandeur. In 1922, when Godward was sixty-one, he turned the gas ring on in his apartment in London and asphyxiated himself because, he wrote, "the world is not big enough for me and a Picasso."

Katherine Angell from
her who brought me
myself
with lo

I wanted to try again with *The New Yorker*'s Harold Ross, now that I was tracing. This time it worked better—Ross looks determined but not quite so thuggish. More like an Easter Island monument.

The thing about art is, you're not going to do it if every time you try something, it comes out badly and makes you miserable. You may be one of the exceptionally rare, wondrously gifted people who can draft a likeness unaided from five feet away, and if so I congratulate you. Most of us simply cannot draw portraits by eye with any level of fidelity and sophistication.

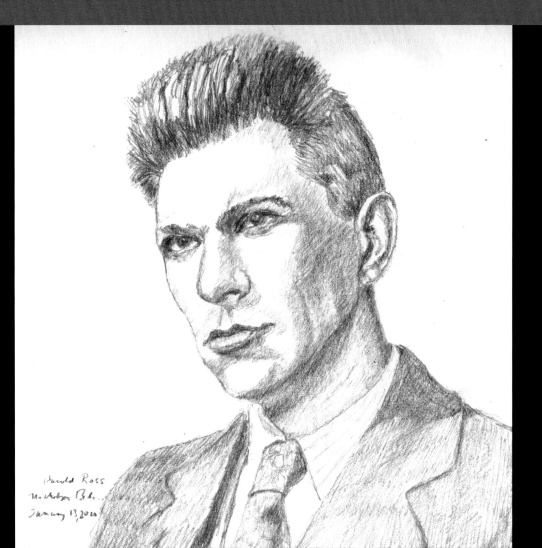

Harold Ross
Nicholson Bak...
January 13, 2020

Instead of tracing, which has become taboo, would-be artists are sometimes given lessons in anatomy and facial geometry. They're shown "écorché" drawings, that is, drawings of flayed people, people who have no skin, and they're taught the names of the muscles of the mouth and cheek, and the names of the bones under the muscles. "The masseter muscle extends from under the span of the zygomatic arch to the lower edge and ascending angle of the lower jaw," explains *Bridgman's Life Drawing*. They're advised to make abstract ovals and crisscrosses and think about "facial planes."

With straight lines, draw the boundaries of the forehead, its top and sides, and the upper border of the eye sockets. Then draw a line from each cheek bone at its widest part, to the chin, on the corresponding side, at its highest and widest part.

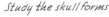

Study the skull forms

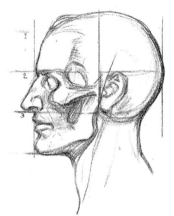

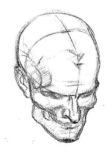

When I begin drawing a complicated, thoughtful person, do I want to think about a grinning postmortem flayed skull? Not very much. Harold Ross could have an eggplant or a bag of pea gravel in his head—what's inside his head doesn't matter—what I care about is what he looks like. If, instead of being taught crude axioms like the "rule of thirds," students tried tracing a face or two or fifteen, there would be no need for skulls and crisscrossed dividing lines. There would just be the face itself, in outline, teaching by example, ready to be refined and molded with shadows, dainty or deep as need be, and filled out with soul.

My daughter, Alice, got quite sick in January, with a fever and a cough. The world entered lockdown.

I kept drawing. I drew Jeff Buckley, singer of Leonard Cohen's "Hallelujah," which begins with an audible exhalation. Also a Lasko box fan in the window. Perhaps I was thinking about breathing and air and fevers, I don't know. Also I drew activist Kathy Kelly, of Voices for Creative

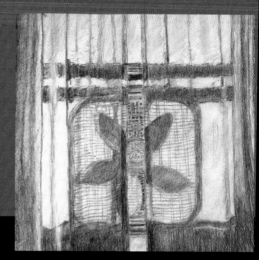

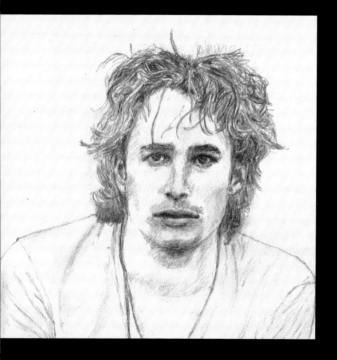

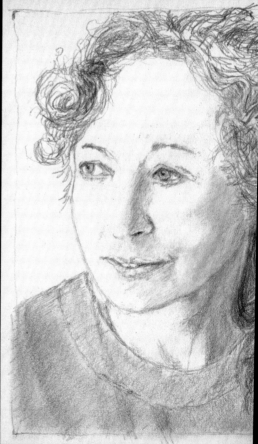

Nonviolence, and writer Emily Hahn with a monkey on her shoulder. I was reading Hahn's memoir, *No Hurry to Get Home*.

For these drawings and some of the earlier ones, I used a Kuru Toga Roulette mechanical pencil that my son gave me for Christmas. It gave me the finest lines I'd ever made with a pencil, and it had a narrow nub of an eraser that made erasing a form of drawing. Half of drawing is erasing—that's where the crucial adjustments come in.

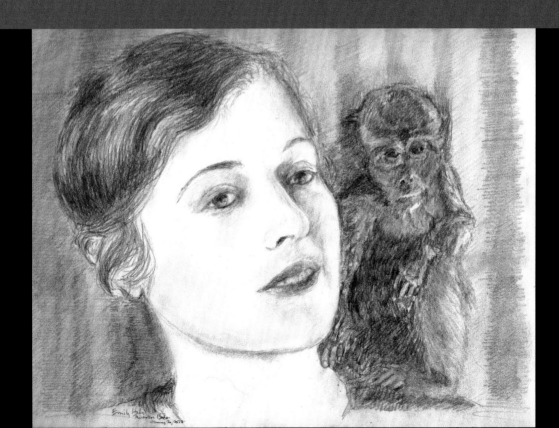

ROUTE 59B
REIGATE

THE COLNE RIVER AT
UXBRIDGE
BY TRAM

THE MALTESE
FALCON

BY DASHIELL HAMMETT

★ A MODERN LIBRARY BOOK

FLOWERS O'THE CORN

FLOWERS FRESH IN HUE AND MANY IN THEIR CLASS
IMPLORE THE PASSING STEP, AND WITH THEIR DYES
DANCE IN THE SOFT BREEZE IN A FAIRY MASS. BYRON
......AND......
HOW NEAR THE CORN GROWS

I spent an hour looking at old travel posters, and then I drew an artist named E. McKnight Kauffer, who designed some of them. Kauffer later made book jackets, and posters for American Airlines. I drew him, and I knew him.

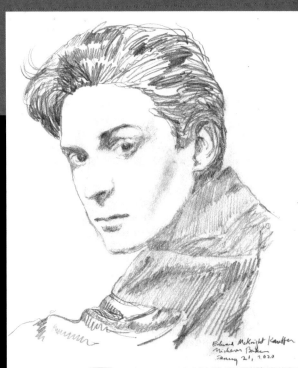

Lena Rivo, a painter of glittering Portuguese seascapes, was offering an online course called "Color Mastery." Great title. "Gouache is the perfect medium that can turn your painting process into pure joy," she said. I signed up.

I did only a few of the exercises she asked us to do, I'm ashamed to say. But I learned a lot from watching her way of freehand drawing, which estimated angles and visualized negative shapes. Her hand moved, stopped, considered, moved again, stopped, like a sandpiper in the surf. And I loved seeing her paint a sunny street in Sesimbra, with the blue sea beyond the hot and cool colors of stucco. A lot of painting is knowing what to paint. Seeing what's there.

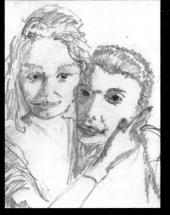
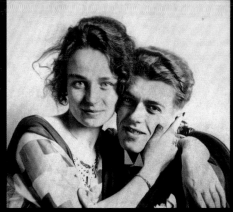
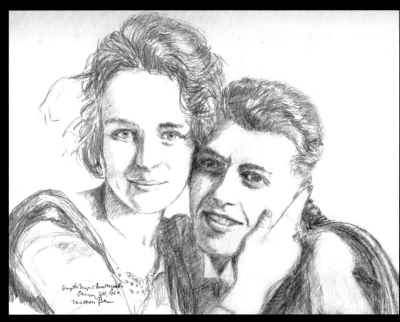
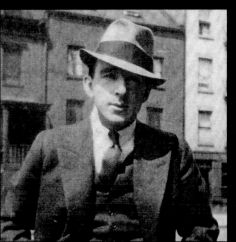
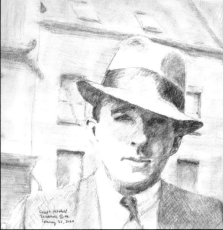

I went back to the Magritte photograph that I'd botched in October—Magritte with Georgette Berger on his lap. Now Georgette looked like herself, and Magritte looked like George Harrison. I had an ecstatic experience drawing the brim of the hat worn by writer Joseph Mitchell, using my finger to blur out the windows behind him.

And I revisited Anaïs Nin. As I finished my second drawing of her I thought about her diary, *Mirages*, which I'd been reading. She wrote: "All America is still in elementary school." I posted the drawing on Twitter, where people liked it. Fun!

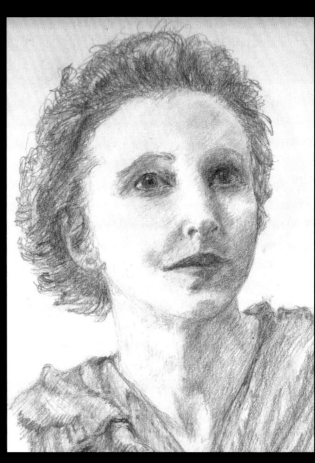

I copied a painting called *Woman with a Red Shawl*, by J. Mason Reeves (1898–1973)—another Pinterest suggestion. Reeves, son of a navy commander who designed the first football helmet, studied at the Pennsylvania Academy of the Fine Arts, and in Rome under Baron Sigismondo Meyer; by his midtwenties he was a well-known member of the Bohemian Club of San Francisco, painting society women and giving talks on

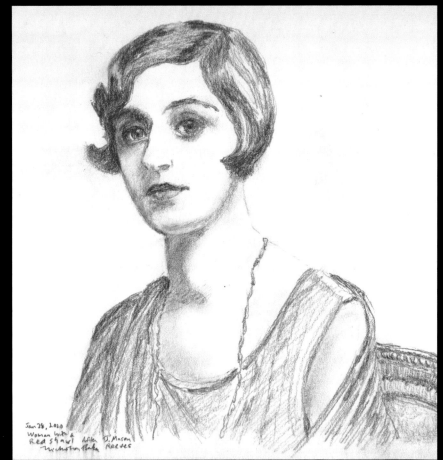

Jan 28, 2020
Woman with a
Red shawl After J. Mason
Washington Park REEVES

"Portrait Painting Today" at artists' associations. By the forties and fifties, his star had dimmed, and he became a board member of a curmudgeonly group called the Society for Sanity in Art, which was violently opposed to modern painting. Reeves wrote letters to the editor and gave newspaper interviews on the evils of modernism, which was, he believed, controlled by the "followers of Moscow." "This underground subversion in art," he said, "is part of the overall Communist conspiracy to create chaos and confusion as a prelude to revolution."

February 2020. It took me three mornings to draw Tracy Chapman. I was scrambling that week—I had to read through the proof pages of *Baseless* and also begin a piece for the *Times Literary Supplement* on the big books of the year 1920. But when I was working on the drawing I was calm. The world was a mess, Bernie Sanders and Elizabeth Warren weren't getting along, but the important thing at that moment was to try to do right by Tracy Chapman's wistful, glowing smile.

While I worked I sang bits of her songs to myself.

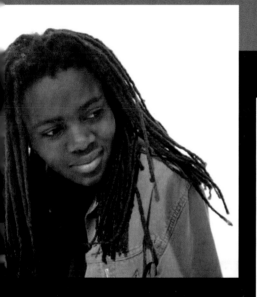

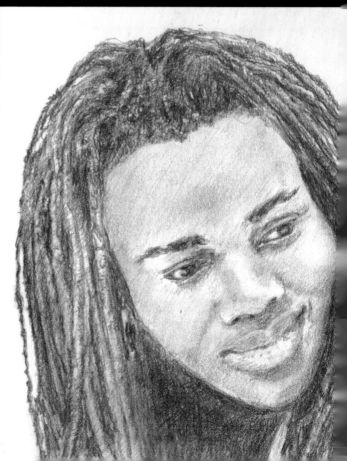

Her biggest hit is "Fast Car," but I also sang "Give Me One Reason" and "Change."
Every so often I took a deep breath and erased a mistake, or deepened a shadow.
The photo is by Andrew Williams from 2003.

I want to do this from now on, I thought—draw people whose lives add beauty.
And paint them, eventually.

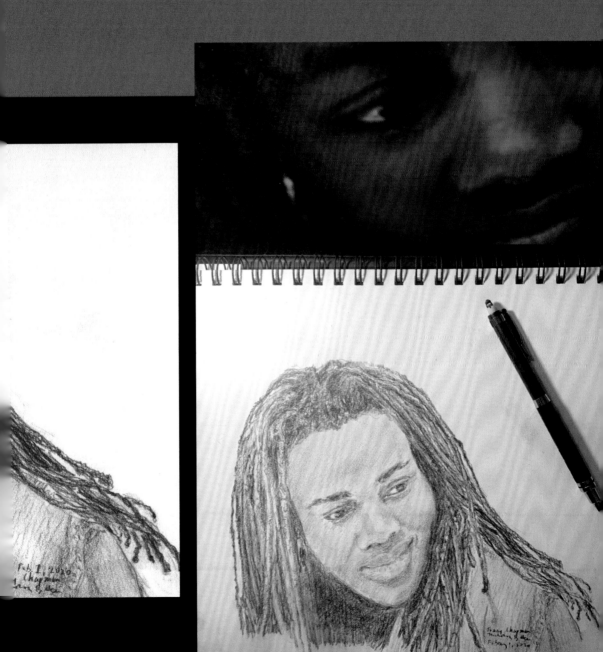

A week later, after the distractions of the Iowa caucuses, I traced a photograph of Jean Stafford, a short story writer. Stafford came out of the Payne Whitney Clinic and wrote a story called "Children Are Bored on Sunday," a masterpiece. Katharine White accepted the story, and the two women became lifelong friends.

My tracing took ten minutes. The drawing took several hours, over two days.

Colin Page wrote to ask me how things were going. I sent him scans of a few drawings, including the drawing of Stafford, which he liked. "My only advice is

to also draw from life," he wrote. "Whether using a paint brush or a pencil, the act of translating the 3-D world onto a flat surface will educate your eye. It's much different than working from a photo that has already been flattened. Draw a coffee cup, a friend sitting with you, the view out the window. Anything."

I thought, Yes, of course I will—someday.

Jean Stafford
Winslow Pohe
February 8, 2020

For most of March I was writing about YouTube for the *Columbia Journalism Review*, but when I'd finished a draft I threw myself back into sketchery. Somebody on Quora recommended a group on Reddit, Reddit Gets Drawn, where people posted pictures of themselves or their loved ones and other people drew them. I liked the idea of doing a portrait that somebody had actually asked for—so I gave it a try.

About Community ...

We are a community for redditors who want to get drawn and redditors who want to draw them! Post a photo of yourself or a loved one, and we'll draw you!

569k **74**
Members Online

🎂 Created Feb 12, 2012

Create Post

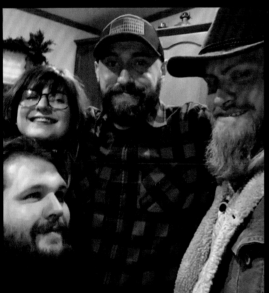

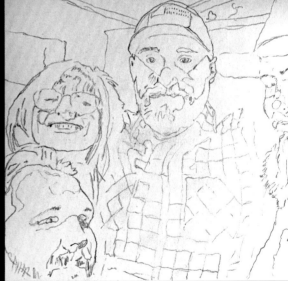

One of the first images I drew was a selfie of four smiling friends. The tracing took me less than half an hour, but I spent two days on the drawing: each smile seemed to have its own story to tell. The plaid shirt alone took two hours—and while I did it I felt utterly happy. A phrase came to me as I worked, and I wrote it down: "The remarkable intransigence of the ulterior pilaster." No idea what it means.

Drawing was rearranging my brain. I could feel it working.

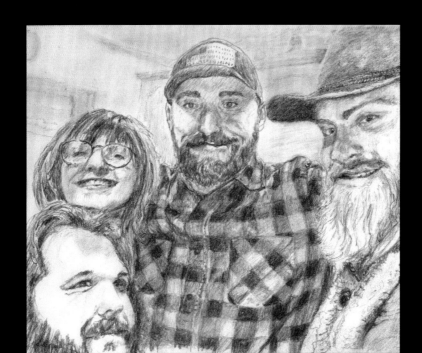

I made the list of the best of Reddit Gets Drawn that week, thanks to the plaid shirt, which encouraged me to keep going. I did one drawing of a couple on their porch, and one of a young man standing in front of a self-portrait by Egon Schiele. The most difficult part about drawing the man, who called himself dadostagram, was his lower lip: full but under tension because of his almost smile. It was the first time I'd drawn stubble, which turned out to be easier than I would have expected—you just tap away at the paper, following the curve of the jaw, and magically it ends up looking like whiskers.

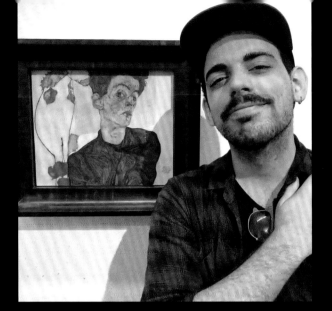

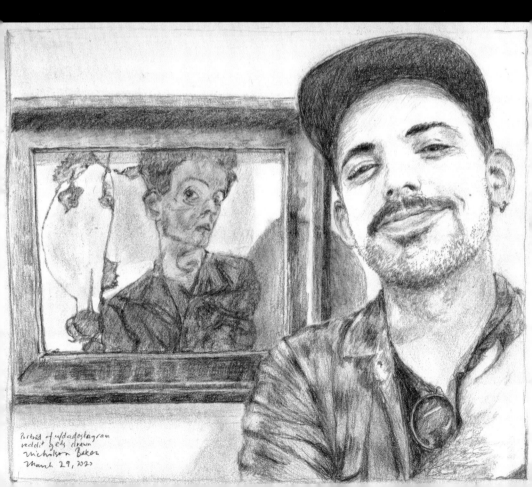

Portrait of u/dadoslagran
reddit gets drawn
Nicholson Baker
March 29, 2020

I made another attempt at a likeness of Dorothy Parker, from a portrait taken in 1925 by theater photographer Florence Vandamm. Parker was famous by then; her poem "Resumé," listing various unpleasant ways to take one's life, had appeared in the *New York World*. I was interested in how you signal the existence of eyelashes when the eyes are in shadow—sometimes a line or two at the far corner of one eye does it.

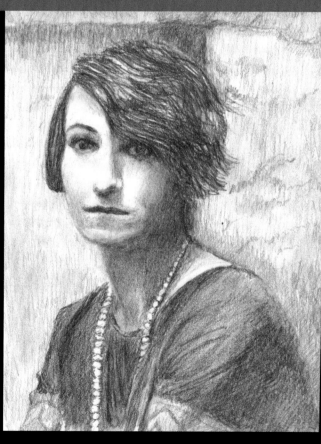

And I discovered Pietro Annigoni, who took London by storm in the 1950s and painted as if he lived during the Italian Renaissance. His egg tempera portraits of nobles and notables, including Queen Elizabeth and Princess Margaret, were impressive, but it was his delicacy of line that really speared through me. I copied one of his drawings—found as usual on Pinterest.

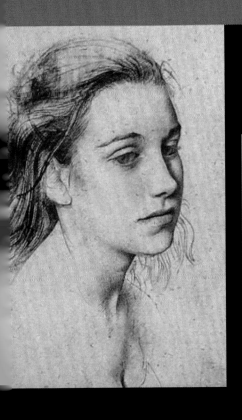

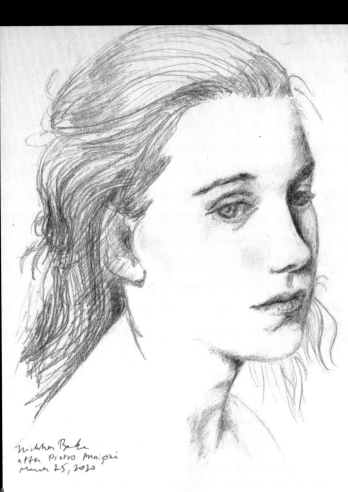

Nicklas Bake
after Pietro Annigoni
March 25, 2020

Annigoni was a puzzle—such a gloomy, violent man, and so good at women's faces. For the cover of *Time* magazine he painted President Kennedy (not very well) and drew President Johnson and the pope. He also painted grand portraits of the Shah and Queen of Iran and of General Mark Clark, who'd ordered the bombing attack in 1944 that destroyed the Monte Cassino monastery. General Clark left his air force jacket behind in Annigoni's studio, and the painter wore it for years afterward. I found a picture of him taken in a sound booth at the BBC, wearing General Clark's old jacket, and I drew it. Two things especially troubled him—the badness of much of modern art, and the chemical injury to great paintings by

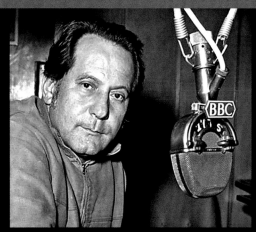

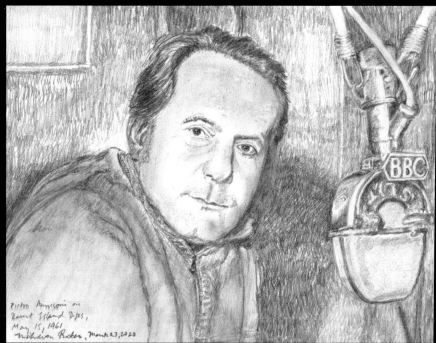

Pietro Annigoni on
Desert Island Disc,
May 15, 1961
—Nicholas Reikes, March 27, 2020

museum conservators. "The over-cleaning of old masterpieces is as destructive as the atom bomb," Annigoni said to a reporter. "They are being ruined forever. This is criminal."

John Canaday, art critic of *The New York Times*, wrote a brutal review of Annigoni's work in 1969. "Mr. Annigoni's manipulation of the materials of drawing and painting has very little to do with art," Canaday wrote. "Nothing, if you ask me." Annigoni lost his left ear in a car accident in 1968; he died in Florence in 1988 at the age of seventy-eight. One of his last projects was painting new frescoes in the dome of the rebuilt Monte Cassino monastery.

A restlessness came over me. I needed a faster, looser way of drawing. On March 30, 2020, I drank half a beer, shivered a little, sharpened an HB pencil, taped a fresh piece of paper onto my computer screen (using Scotch tape because I hadn't yet bought masking tape), and traced circles and spirals over a photograph of a young Igor Stravinsky in a tuxedo, wearing a pince-nez. This was an entirely

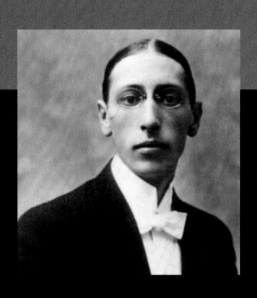

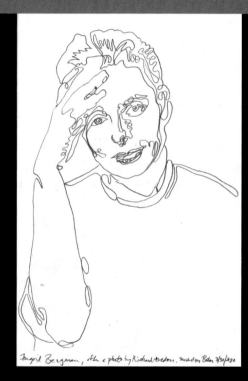

Ingrid Bergman, after a photo by Richard Avedon. Monday Baker 3/30/2020

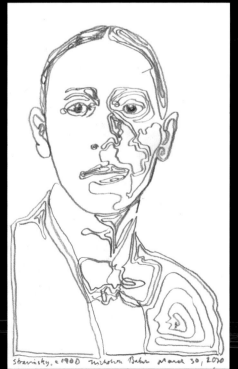

Stravinsky, c1900 Nicholson Baker March 30, 2020

different way of moving around the page—as if I was in a bumper car, swerving, making spur-of-the-moment decisions about whether my line should veer off sharply or continue on the oval. It was a little like the gesture drawings my mother had us do, except that now I was tracing. I taped up more pieces of paper and drew Ingrid Bergman (from a photograph by Richard Avedon), Javier Bardem, and Chevy Chase.

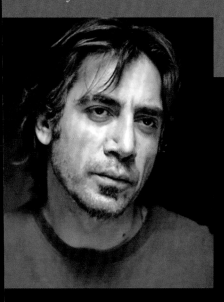

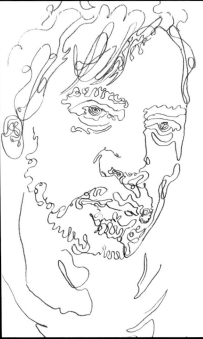

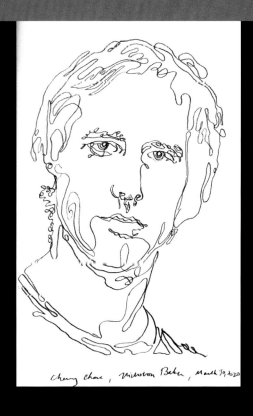

Chevy Chase, Milwaukee Baker, March 30, 2020

Whistling a tune from *Petroushka*, I also loop-traced editor Robert Gottlieb. (I was reading his memoir just then and liking it.) And then editor David Rosenthal, who'd published some of my books.

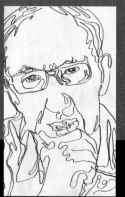

Rosenthal looked as if he'd gotten an ill-advised tattoo on the side of his forehead, so I put away that drawing and produced a second version with less forehead graffiti, along with a normal sketch of him that included the finger-blurred bookcase behind. I posted these on Twitter.

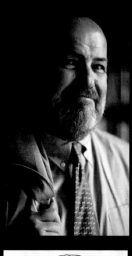

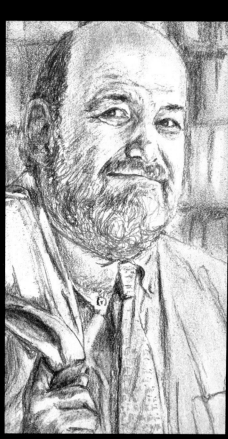

A single photograph of Stravinsky and his pince-nez had somehow set me off on all these eager, swervy travels. Maybe I was thinking of Picasso's drawings with light in *Life* magazine, and his 1920 pencil portrait of Stravinsky sitting in a chair with his fingers intertwined, one of the best portraits Picasso did. The work is, if not loosely traced, then closely copied from a photograph, and there's a similarly posed likeness of composer Erik Satie, also from 1920. Both composers are seated in the same wooden chair, as is Picasso himself in a self-portrait from that period.

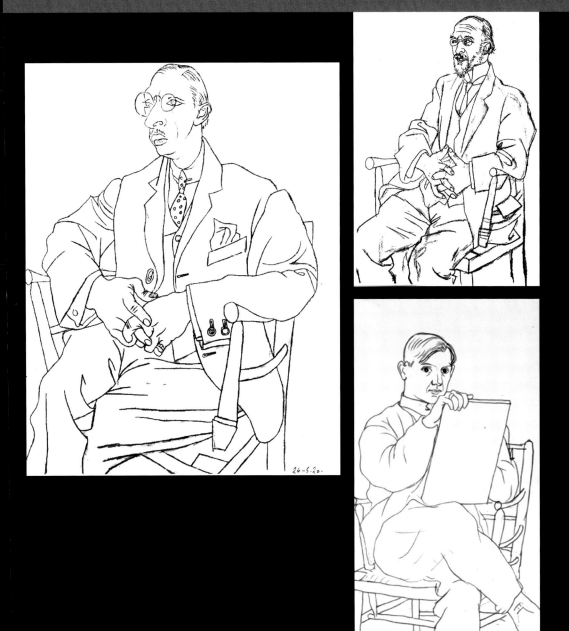

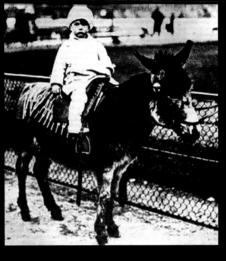
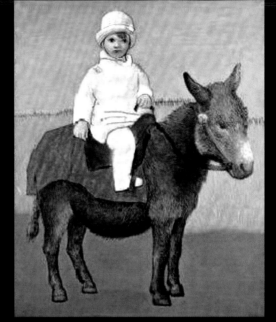

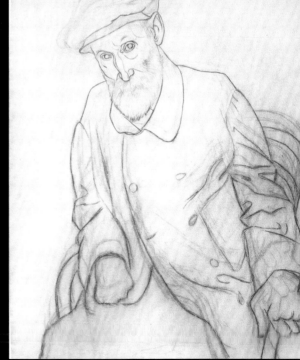

Like Edgar Degas, Picasso was a camera buff and, at times, a careful tracer. In 1923, for instance, he decided to paint his young son riding on a donkey. He wanted his son to look like his son, and the donkey to look like a donkey, not like a cubist deconstruction—so he traced the photo, simplifying the background and shifting the animal's hind legs a bit.

Picasso traced the wrinkles in Renoir's coat, along with his arthritic hands; at one point he seems to have slid the paper down and erased the original tracing of the hand and the chair. He stylized the details of a photograph in a painting of his first wife, Olga Khokhlova, formerly a dancer in the Ballets Russes. I wish he'd painted the background.

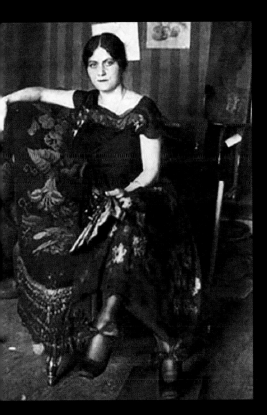

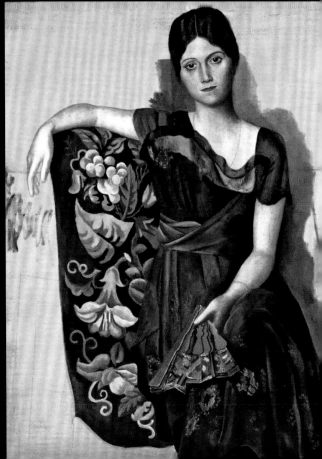

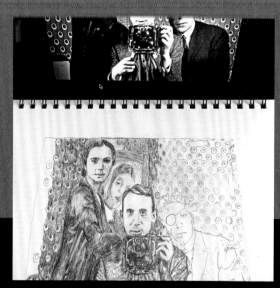

April 2020. I kept taking pictures of clouds, but I didn't paint them—wasn't ready. Instead I found a striking 1926 photograph by André Kertész, "Self-Portrait with Friends," taken in a hotel room in Paris, and I copied it, doing my best to catch the boyish

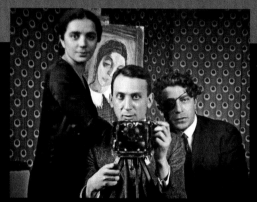

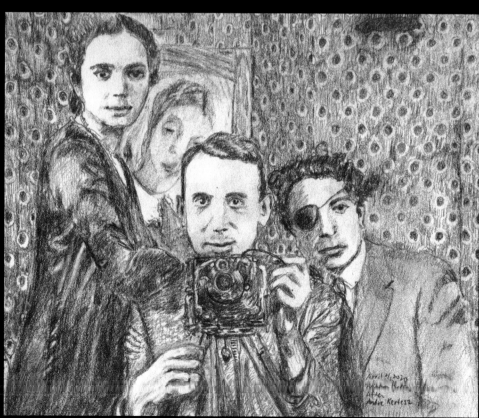

intensity of Kertész's gaze and the almost comic melodrama of the wallpaper. I drew standing up, with my glasses off and my computer and spiral pad positioned on a small table that I'd put on top of my desk. More than a hundred drawings came into being this way—it was easier on my back.

I think the woman in the picture with Kertész is Elizabeth Saly, whom he later married; I don't know who the man with the eye patch is, but he's got some good hair.

For my dad's birthday I drew a group portrait: him, my son, and me.

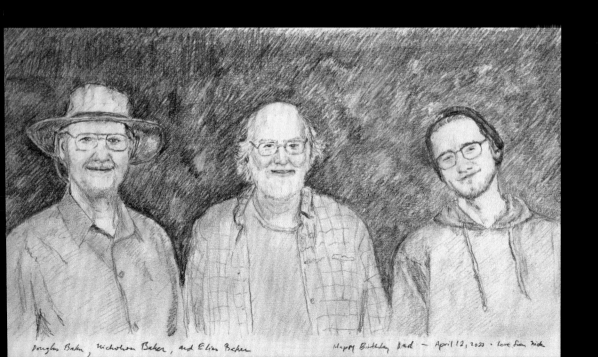

Douglas Baker, Nicholson Baker, and Elias Baker Happy Birthday Dad — April 12, 2020 · love from Nick

Now I had two drawing styles: (1) fast loops and related wiggling movements and (2) traditionally shaded and erasefully slow. The loops (or call them "active tracings") were more fun, but the traditional drawings held more detail, and because they took more time, I learned more from them.

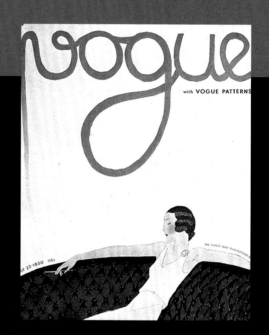

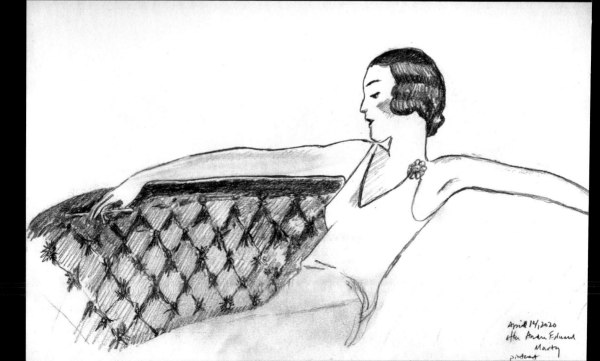

April 14, 2020
after André Edward
Marty
pintrest

What I needed, I thought, was a third style, flatter, snappier, more cartoonlike, with sharper outlines, something I could color in with markers, watercolor, or gouache. I bought some Sakura Pigma fineliner pens and studied art deco illustrations for *Vogue* and *Harper's Bazaar* and *L'Illustration*. André Édouard Marty was one of *Vogue*'s stars, a master of open page space, along with Helen Dryden, Erté, and Georges Lepape. In pencil, waiting for the pens to arrive, I copied Marty's long-armed woman reclining on a couch, and Erté's gracefully droopy *Michelle*.

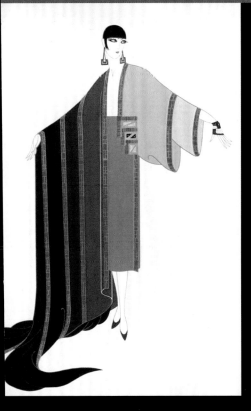
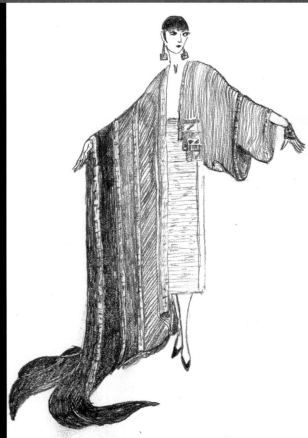

Adam Schlesinger, musician, died of COVID. Schlesinger, half of Fountains of Wayne, who wrote brilliant, joyous songs with clever chord changes, spent his last days on a ventilator, suffocated by a virus. I thought I should draw him, but I couldn't.

The disease was bad everywhere. I saw a tweet from an Italian health worker, Nicola Sgarbi, from Modena. "After 13 hours in ICU after taking off all my protective devices, I took a selfie," he said. "I am not and I don't feel like a hero."

He had a one-year-old daughter.

I drew him, wept briefly, and posted the drawing on Twitter.

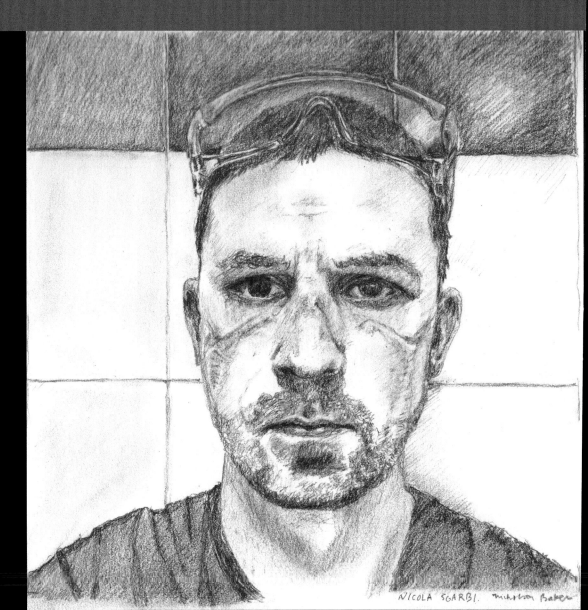

NICOLA SGARBI. Nicholson Baker

People started wearing masks. On Reddit Gets Drawn, though, I could see mouths, noses—whole faces. I got better at understanding how mouths work. There's a signaling system of shadow shapes at the corners of the mouth, and if you don't pay close attention to it, you can lose the likeness.

I drew a woman who identified herself as im2tired4thisshit, a man in a hood with the username KnightTop, some happy couples, and a man standing next to Neil Armstrong's space suit.

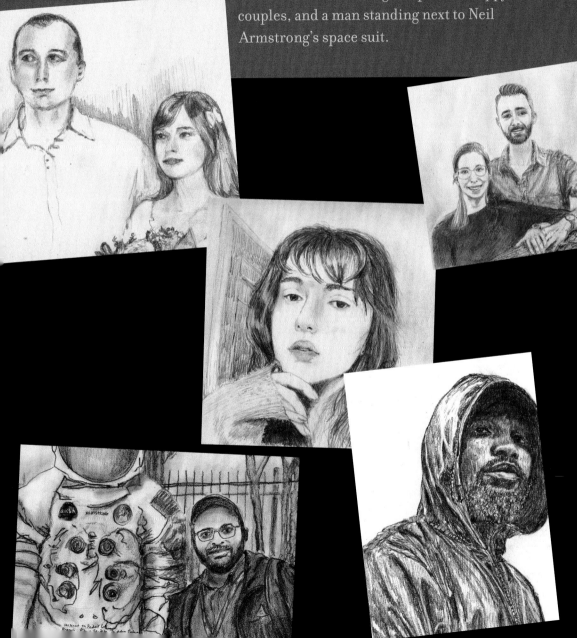

Sergio Toppi, *Sharaz-de: Tales from the Arabian Nights*, Éditions Mosquito

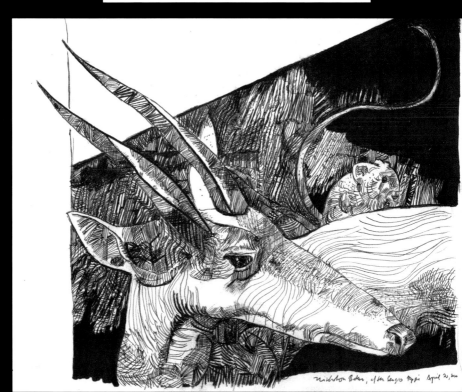

Some boxes of fineliner pens arrived. One of the first things I did was to copy a drawing of an eland by Sergio Toppi, a master crosshatcher who died in 2012. I used a Pigma 005 pen, the finest tip, to make the wavy lines on the animal's muzzle. Then, over a photograph by Roberto Serra, I traced a loop drawing of Toppi himself. It didn't turn out very well, so I came up with a better version of him, with crosshatching.

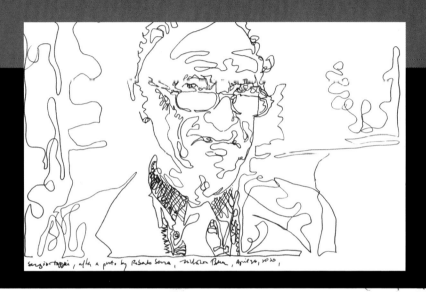

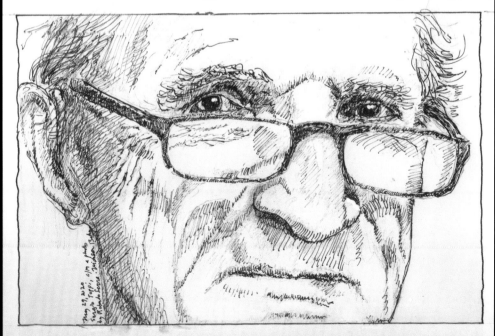

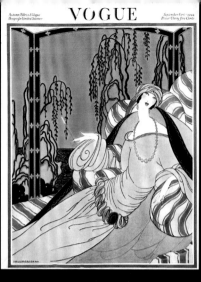

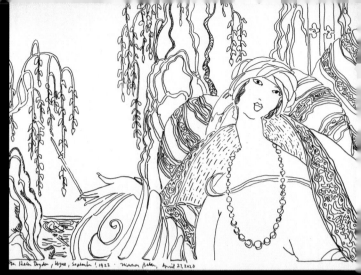

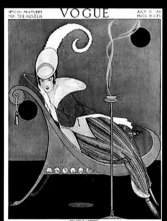

I made a pen-and-ink copy of one of Helen Dryden's many astonishing covers for *Vogue*, using line patterns to stand in for Dryden's colors.

In addition to her magazine covers, Dryden devised the swoopy interiors of Studebaker sedans. "This year's stand-out car in style because designed by Helen Dryden!" said a Studebaker ad in 1936. She made a fortune as an industrial designer but died in poverty.

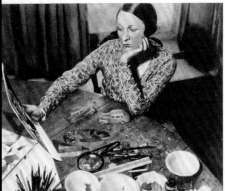

EXCITING NEW *Studebaker* STYLING
INSPIRED BY GIFTED HELEN DRYDEN

IN these spotlight cars of 1937, famous Helen Dryden, foremost stylist of her day, again has collaborated with Studebaker's distinguished body engineers to create glorious new motor car body design, refreshingly vigorous and smart.

Definitely different in appearance from any other cars you'll see, from their silvery "Winged Victory" radiator grilles and louvers to their impressively air-curved rear decks, these spirited new Dictators and Presidents achieve their distinction by adhering to fundamental good taste.

Their long flowing, beautifully rounded hoods have a graceful one-piece top devoid of the customary unsightly center ridge. It lifts up from the front for radiator and engine servicing and holds securely in position till pulled down again.

The gleamingly lacquered front fenders of heavy steel are wider and lower than any others you'll see . . . and they're cleverly air-foiled in true airplane manner. The torpedo shaped headlamps are

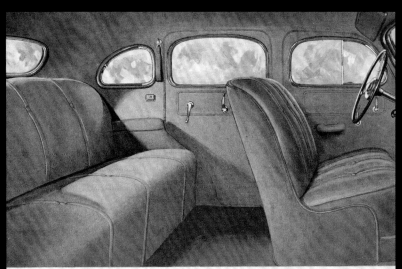

INTERIOR OF STUDEBAKER SIX-PASSENGER SEDAN STYLED BY HELEN DRYDEN

I scrolled through the photos on Reddit Gets Drawn and drew the humans therein. A bearded man with glasses, username squeegie_freak, wrote that he liked the "chaotic simplicity" of my portrait.

Ink is exciting, up to a point, because you can't erase, except in Photoshop afterward, but it wants to make hard edges, whereas graphite gives you soft edges,

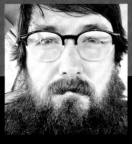

squeegie_freak

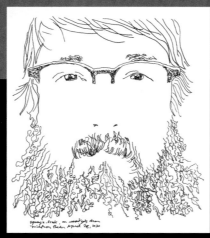

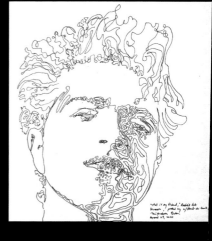

Laliza

edges that you can soften further by going over them gently with a Faber-Castell pencil eraser. So, for instance, I made a pen-and loop version of a Reddit beach-goer named Laliza and it was bad—too wiry. Then I made a second, traditional pencil drawing of her and posted it, for a while Laliza in pencil was my most-viewed drawing on Reddit.

I chose pencil to draw Jean Cocteau (for the second time)—modernist poet and Renaissance man, superb draftsman, friend of Stravinsky and Picasso. I took a long time with his fingers, and erased into being the wisp of cigarette smoke in front of his eye.

Jean Cocteau, portrait of Glenway Wescott

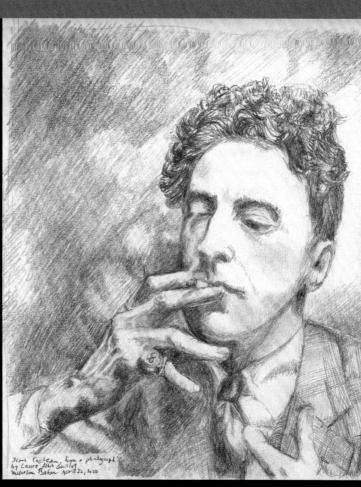

Jean Cocteau

Portrait of Yul Brynner

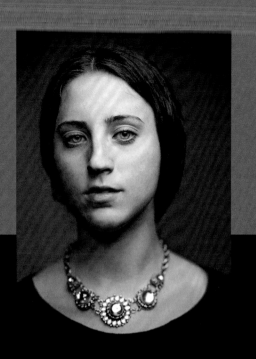

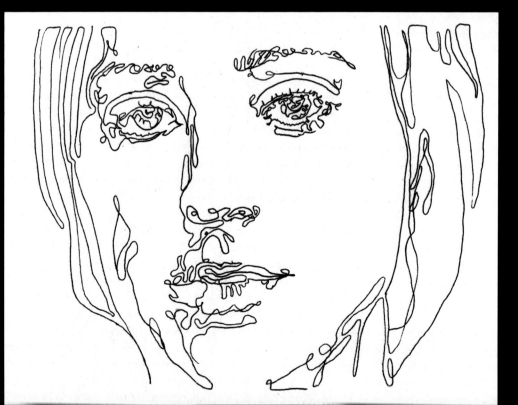

Toward the end of April I visited Unsplash again—Unsplash is that place on the web where you can find millions of royalty-free photos. Luke Braswell, a photographer from Oklahoma City, had uploaded a picture of a woman with a heavy necklace and a long-ago-and-faraway expression. I took a few minutes to make an active tracing of her face, close-cropped. It was the loosest loop drawing I'd done. I added some color in Photoshop.

The month of May, I decided, would be a month of painting. I needed more color.

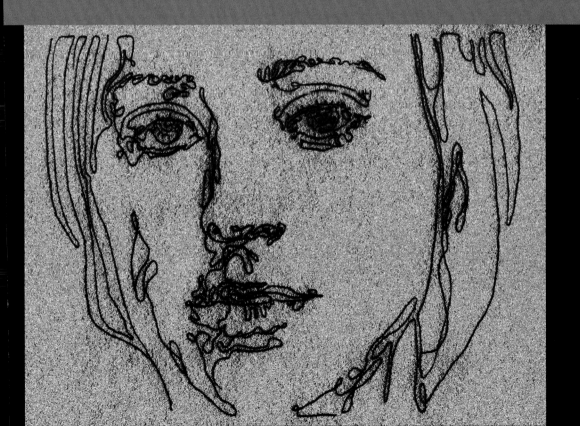

May 2020. On reflection I found I wanted most to paint and/or draw trees—clumps and boughs and trunks and allées. I'd added several names of tree-minded artists to my inner museum: Daniel Garber (1880–1958), Santiago Rusiñol (1861–1931), and Henri Le Sidaner (1862–1939). Plus two who are living now: Cuban surrealist Tomás Sánchez, and Dina Brodsky, who draws trees with a ballpoint pen and is a star on Instagram.

Daniel Garber

Daniel Garber

Santiago Rusiñol

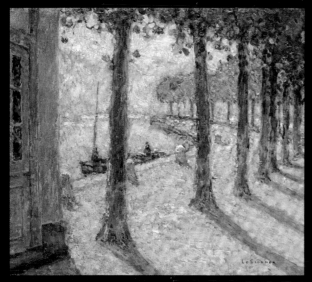

Henri Le Sidaner

Santiago Rusiñol

Daniel Garber won gold medals, had shows, taught for decades at the Pennsylvania Academy of the Fine Arts, and died at his house in Lumberville, Pennsylvania, when he fell off his balcony while clipping ivy. Why wasn't he better known?

I moved my gouache paints and an easel from Jerry's Artarama out to the porch.

Dina Brodsky

Tomás Sánchez

Daniel Garber

But still I craved drawing people. People have eyes; they look straight up at you from the paper when you've finished. Sometimes they look away at an angle, and that's good too. Trees have arms but no eyes.

Albert Henry Collings, a now-forgotten portraitist, won a gold medal at the Paris Salon of 1907. I came across a work by him, *Portrait of a Lady*, and looped it with a Sakura pen at five a.m. on a Monday morning, sitting at the kitchen table. I was

Albert Henry Collings, *Portrait of a Lady*

more cautious this time about venturing out from the shoreline of the woman's hair into the faint shadow under her cheekbone—it felt risky, like rowing out into the open ocean.

For reasons I could not fathom, nobody had drawn a happy man on Reddit named _thelonerambler_ and his son. "I'm going to print it and hang it," he wrote. "My wife loves it too!" Boy, that felt good. Drawing was helping me make human connections in the middle of a pandemic.

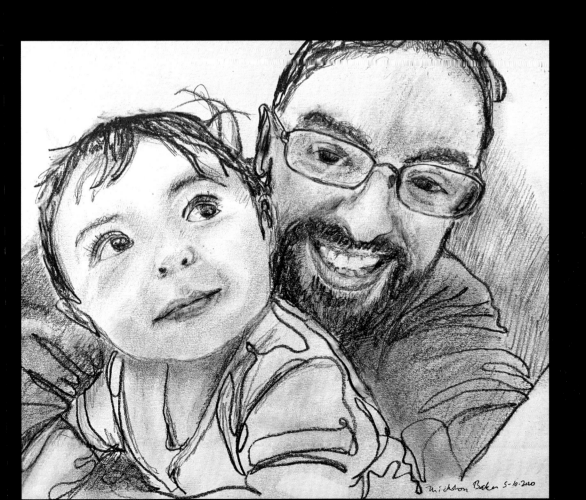

To remind myself how paint worked, I filled some squares with shades of gouache. I still couldn't pilot the brush—it pretended to have a point, but it gave way: it had no point. After some internet searching, I bought a set of water-based acrylic paint markers from the Chalkola company. They had a hard, porous plastic nib that dispensed opaque acrylic paint in lines or dots or dashes, and you could color in larger shapes with them, as if they were crayons or alcohol-based markers.

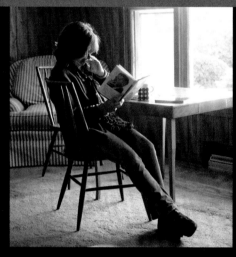

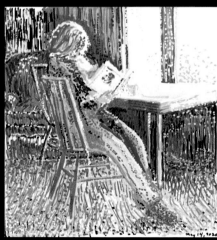

Before Photoshop

After Photoshop

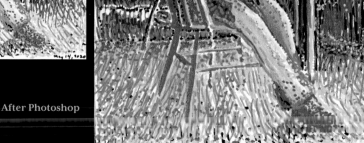

Using the Chalkolas, I painted a picture of M. in a sunny room. The next day, I copied a painting by Carole Rabe. I used linen canvas rather than paper for these paintings so that the marker nibs wouldn't abrade the surface, and I striped and dotted the colors to get a livelier play of light. It didn't feel like painting; it felt like drawing—precise enough that I could sketch in the cover of a *National Geographic* in my copy of Rabe's painting. The light blue marker was awfully bright, though. I adjusted some of the colors down in Photoshop.

Before Photoshop

After Photoshop

I bought more paint markers—a nice set by Uni Posca and some fancy ones by Molotow, maker of spray cans used by graffiti artists.

For a week or so, I marker-painted every day, shaking the pens to mix the pigment and pumping the tip a few dozen times against the page to get the color flowing. It took me four hours to make a version of Henri Le Sidaner's dappled

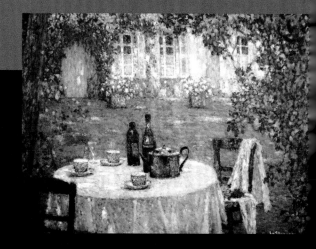

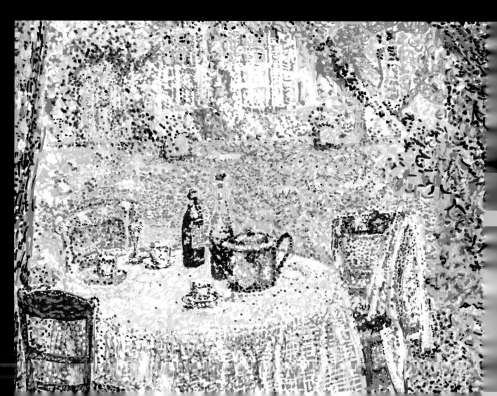

La Table au Soleil. Le Sidaner painted it in 1910 in Gerberoy, a picturesque village in northern France where he had a house.

In my quest to get subtler colors out of a limited palette, I kept madly dotting, and sometimes I dapple-dabbed with a gouache-tipped brush as well.

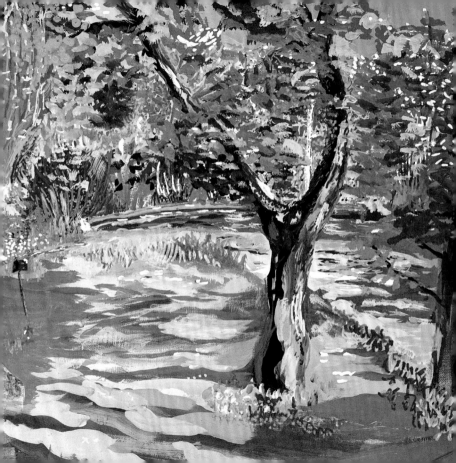

I painted two paintings from life: one looking out the porch window, and one looking at a bottle of beer on the table in front of me.

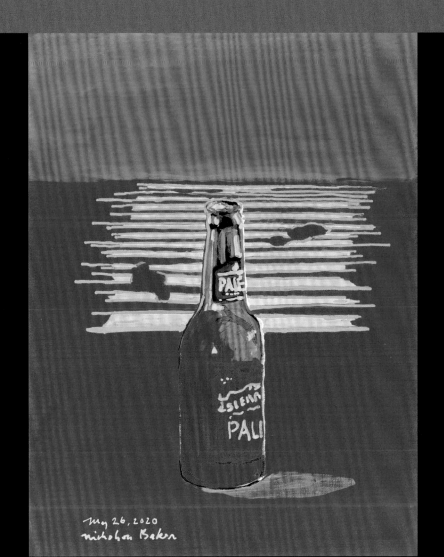

May 26, 2020
nicholson Baker

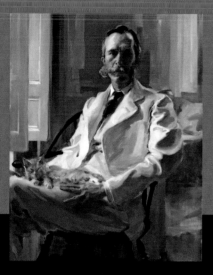

My most ambitious effort was a copy of Cecilia Beaux's painting of Mr. Drinker and his cat. Could I re-create it with acrylic paint pens? Worth a shot. I taped a piece of canvas to my screen (I recommend the pads of primed linen by Centurion, made in China), and I used an ochre-colored pen to trace around the dimly visible shapes and shadows. Then I began dotting. I dotted on and off for three days. Mr. Drinker's face was almost

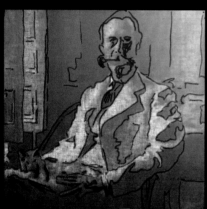

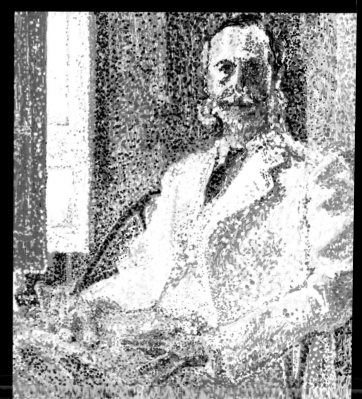

impossible. There was a phase in which he looked like a screaming pope. It was bright on the porch in the afternoon, and my eyes hurt.

I was happiest painting the cat, which went from nothing to a sleepy sunlit fluffball with the help of some pale green and light blue tucked into the shadows.

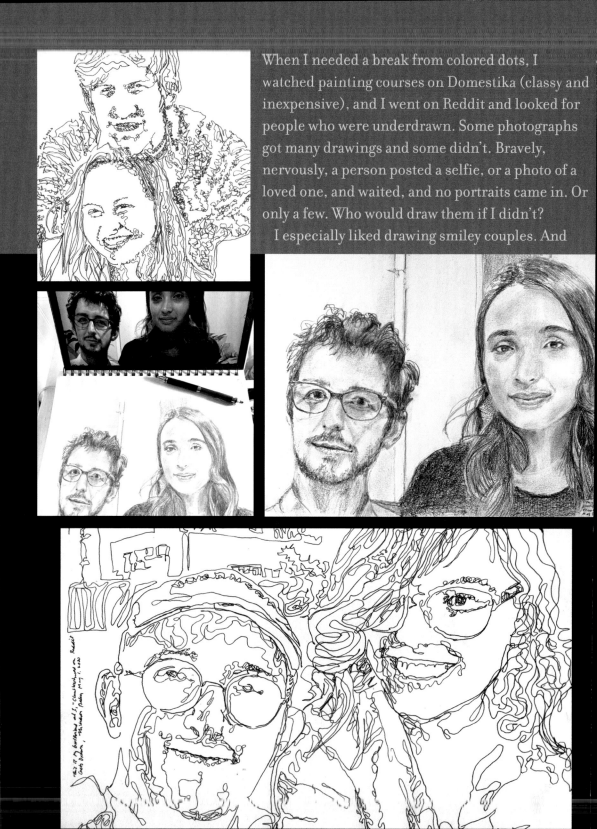

When I needed a break from colored dots, I watched painting courses on Domestika (classy and inexpensive), and I went on Reddit and looked for people who were underdrawn. Some photographs got many drawings and some didn't. Bravely, nervously, a person posted a selfie, or a photo of a loved one, and waited, and no portraits came in. Or only a few. Who would draw them if I didn't?

I especially liked drawing smiley couples. And

parents and children, and people and their dogs. Actually I liked drawing every sort of person, except people with septum piercings, because it's too difficult to draw shiny hardware when it's lurking in the shadows of a pair of nostrils. Nostrils on their own are hard enough.

The rules of the Reddit Gets Drawn subreddit say: "This is a good deeds sub. Art you make should be a gift for the submitter." The submitter's gift is the photograph. The artist's gift is the drawing. What a simple, beautiful transaction.

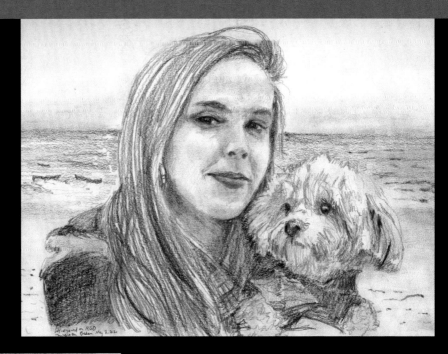

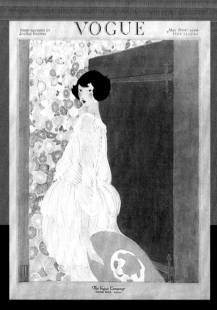

One of my last gouache paintings for May—and for many months afterward—was a copy of Helen Dryden's *Vogue* magazine cover from a hundred years ago. It's of a woman in front of a door. (The actual cover for May 1920 has more pink in it than the faded version I saw on Pinterest.) I decorated the door using two sizes of nail, dipping the nailheads in puddles of gouache. Not quite sure why. An urge to keep dotting?

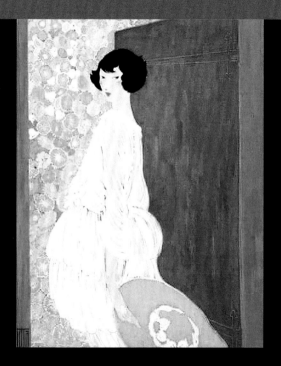

It's sad, I thought, that so few magazines use painted covers now. And sadder still that the magazines themselves are dying, like the thirsty, stumbling dinosaurs in *Fantasia* after the comet hits. Starved of ads, atomized by the internet. *Down East* magazine used to have a painting on the cover every month. So did *Popular Science*, *Popular Mechanics*, *Silver Screen*, and *Yankee*. And of course *The Saturday Evening Post*, and *Field & Stream*, and *Photoplay*, and *Picture Play*, and *Shadowland*, and *Collier's*, and *Time*, and *Fortune*, and *Amazing Stories*, and on and on. The American newsstand was an art gallery.

Can we go back? No. Learn from the greats. Make it new. Paint what's true.

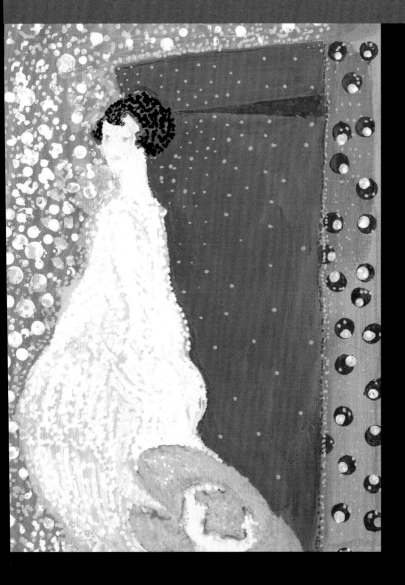

Gretchen Dow Simpson (born 1939) is one of my magazine cover-art heroes. She's painted something like sixty covers for *The New Yorker*. She created a new genre of clapboarded reposefulness and grace.

Simpson worked as a typist in

Boston after taking painting classes at Rhode Island School of Design. She was a guide and a photographer at the New York World's Fair in 1964, and then she worked in an advertising firm while making funky papier-mâché jewelry in the evening. Her *New Yorker* covers were rejected for nine years; then, in 1974, they bought something: a drawing of the front entrance of a friend's hallway, based on a Polaroid. She calls her work "painting from photographic life." I learned this watching a video about her on the website of the Providence Art Club.

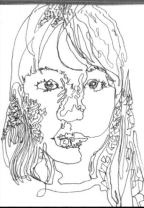

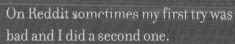
On Reddit sometimes my first try was bad and I did a second one.

Sometimes, as with a photo of a woman in a headscarf, I did two drawings and posted both of them—some digital color added.

Once I drew a man with scars on his eyebrow and forehead. He called

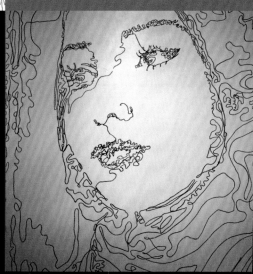

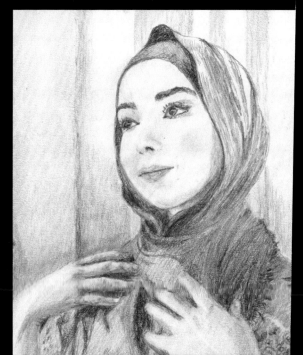

himself halalguy. A scar, I discovered, is just light and shade, like everything else. It can be drawn.

Halalguy commented on my portrait of him. "Wow, looks amazing," he said. "I really appreciate it."

Thelonerambler wrote to ask me to draw his wife holding their baby, which I did. I was feeling glum when I began and by the time I was finished I was weirdly giddy: the power of drawing smiles.

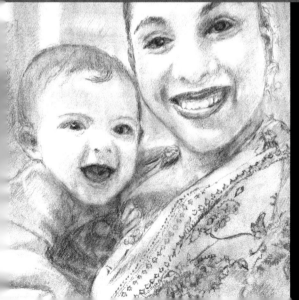

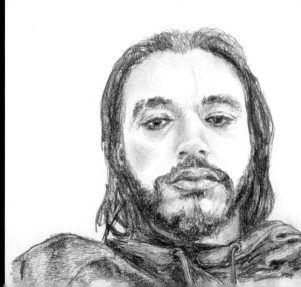

Franklin Booth

Ian Sidaway

Brian Kliewer Meindert Hobbema

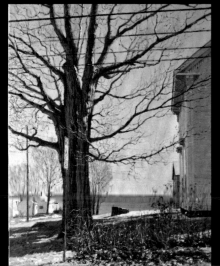

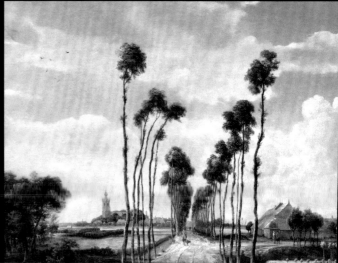

I collected more artists of trees: Franklin Booth, Ian Sidaway, Brian Kliewer, Meindert Hobbema. My plan, which fizzled, was to draw or paint one tree every day. I did ink out a detail from a leaning triple treescape by Franklin Booth to try to understand how he rendered bark so absurdly well.

With paint pens, I added psychedelic colors to a pencil drawing I'd done of William James. I also colorized Sergio Toppi.

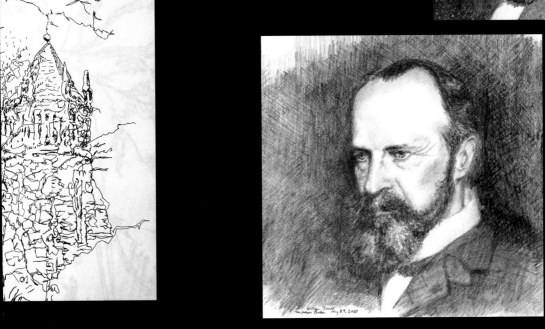

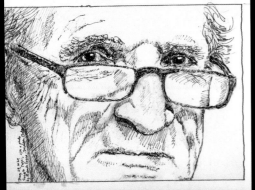

June 2020. I knew nothing about the people I was drawing on Reddit, and yet because I'd studied their faces for hours—their touchingly nostrilled, brave, uncertain faces—and done everything I could to record their singularities, I felt they'd confided in me. For one reason or another, they wanted to be seen. The rule of the subreddit was anyone who was drawn had to post a thank-you to each artist, regardless of what they thought

of a given attempt. And most of them did. In fact, most of
them were wildly appreciative.

"Seriously not one drawing?" wrote one man in a
knit hat and a bomber jacket who'd posted a picture of
himself walking down a rocky hillside with his beaming
fiancée. "Didn't realize we were that hideous."

That made me draw the two of them. "Wow, this is
fantastic, we love it! Thank you!" the man replied.

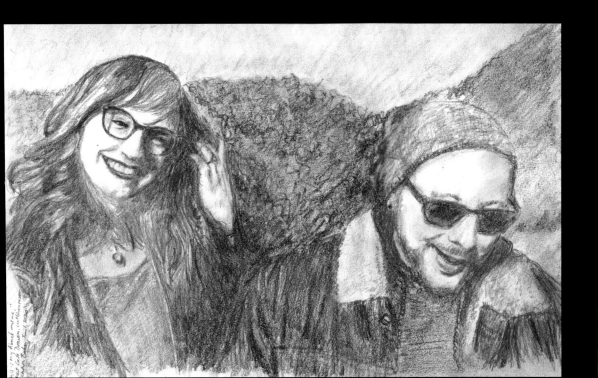

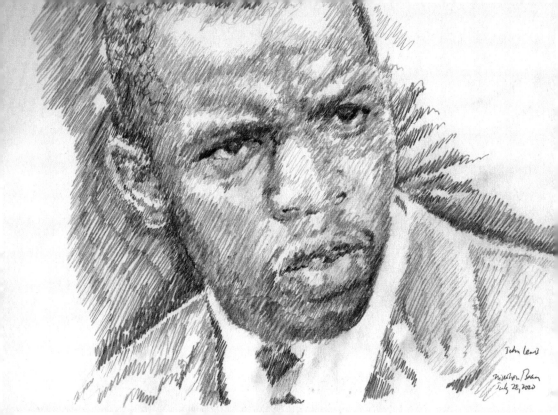

John Lewis

Winston Dean
July 28, 2020

July 2020. *Baseless* was published, and I began research on a magazine article about the origins of COVID. So I did very little drawing. Back to the study of horrible things.

But when John Lewis died, I posted two drawings of him on Twitter. One from the 1963 March on Washington, and one from a photograph taken in 1961, after he was arrested for using an all-white bathroom. I liked the strength in his eyes.

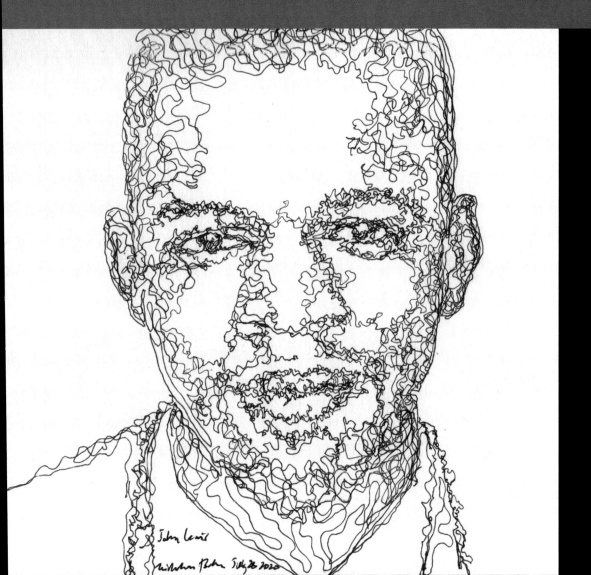

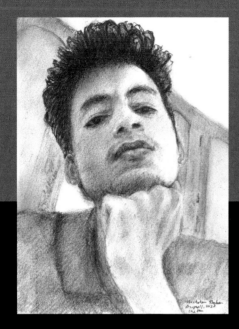

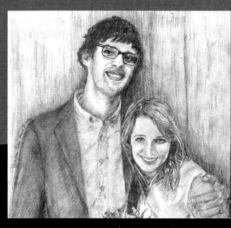

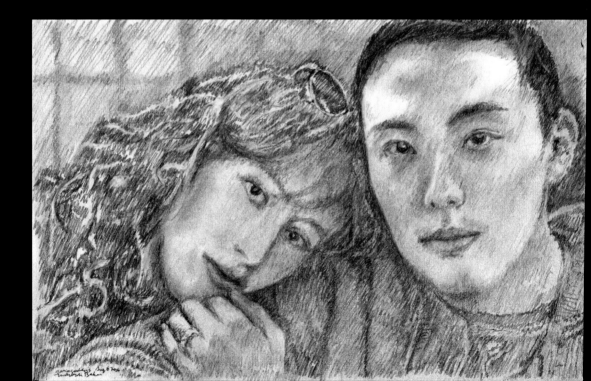

In August I went back to Reddit and found about twenty underdrawn people that I wanted to draw. There was a woman in a car calmly waiting out her son's tantrum, a man with his chin on his knuckly hand, three happy couples, and a family of five with big "say cheese!" smiles. And others. Nobody had done the family of five, so I made a group loop drawing with a ballpoint pen. The dad's comment was "Wow. Thanks." He didn't like it, in other words. I looked at my drawing again and realized I'd made his family look insane. I felt bad, and I messaged the dad that I'd try again.

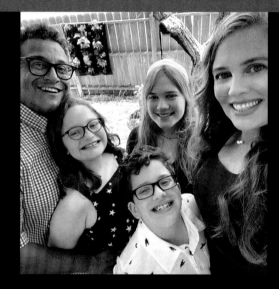

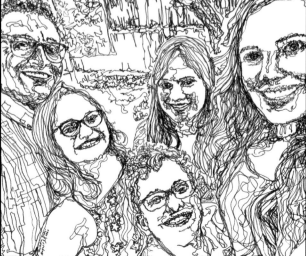

In September I did an ink drawing of a sad-eyed Russian landscapist, Isaac Levitan, from a painting by Valentin Serov. (Color added in Clip Studio and Photoshop.)

Levitan, impoverished, orphaned, homeless, studied at the Moscow School of

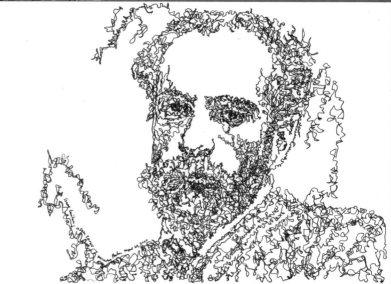

Painting on a scholarship, sleeping in empty classrooms. When Jews were ordered to leave Moscow, he moved to a nearby village. In 1885 he moved in with Anton Chekhov and his family. Chekhov drew him. He died young of a bad heart. His landscapes, with and without trees, are heartbreaking. I wish I had known about this man a long time ago.

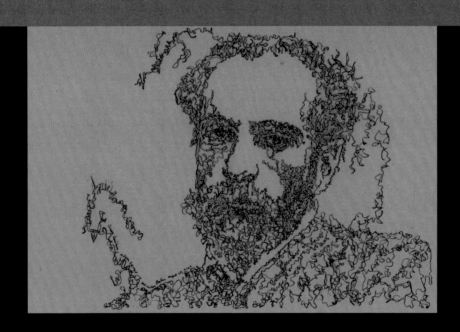

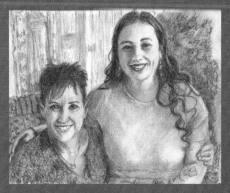

I carried on with the Reddit project—I now thought of it as a project, or at least a subproject. I drew a mother and daughter, people with tiny babies, people with large animals, and two grandmothers. I had to move the grandmothers closer together, but otherwise I drew what I saw. I was happiest with the drawing of the

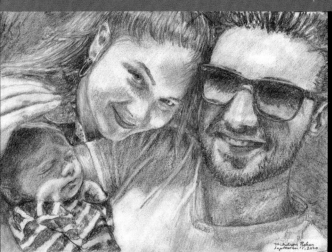

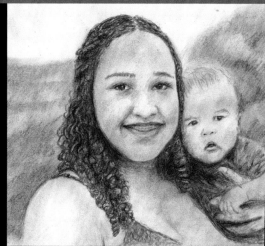

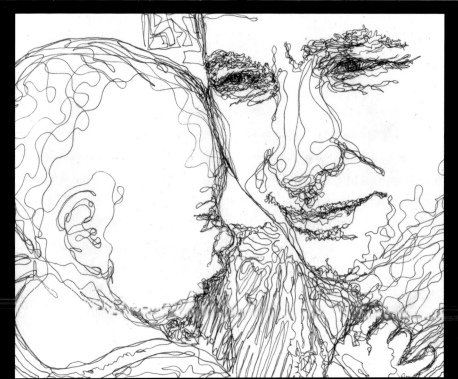

woman shielding her baby's head: hands are difficult, and I managed to get the upward reflection of a stripe of pajamas onto an infant's cheek. Nobody had drawn this picture!

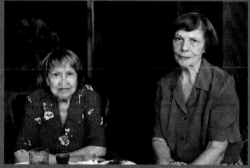

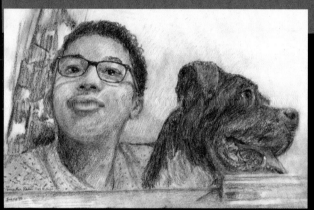

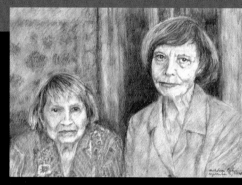

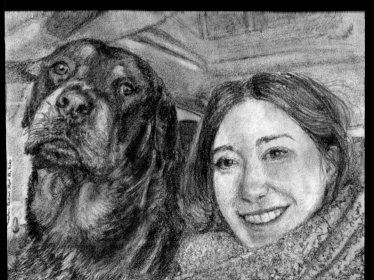

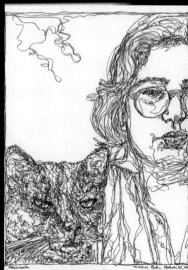

I also drew more happy couples—because why not?—and people whose subject line just said "This is me!"

It amazed me to see how many different kinds of smiles and near-smiles there were in the world.

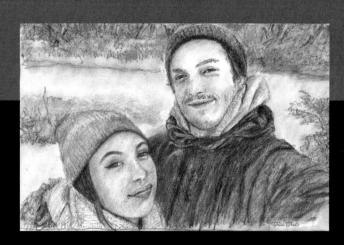

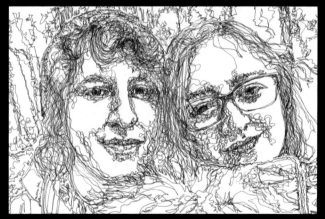

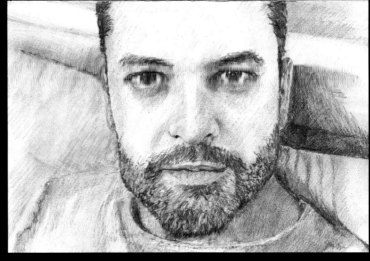

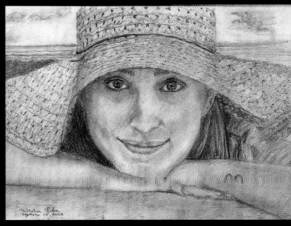
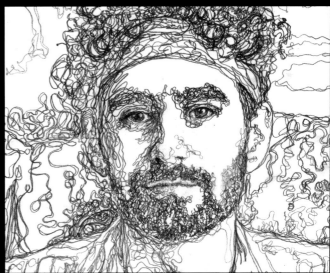

Toward the end of September I discovered another painter of trees, Trey Friedman. Friedman has made a numbered list of 180 trees, mostly sugar maples, that stand on a certain stretch of road near where he lives in Connecticut. His goal is to paint as many of them as he can. He writes that he wants to "understand my own intangible connection to these crucial giant creatures."

Friedman has Parkinson's disease, which makes things more difficult than they were. The paintings are large, and he uses the grid system to transfer his charcoal

drawings to the canvas. His favorite pencil is the Ticonderoga because it has "the best eraser in the world."

I asked him about tracing—whether I should be ashamed of doing it. He told me to look up Degas and Norman Rockwell. "Tracing is one of the essential, common tools of mastery," he wrote. "Michelangelo traced every drawing he did for the Sistine Chapel, using a rotary punch tool. Every artist since then has commonly traced for educational reasons and simple pragmatics."

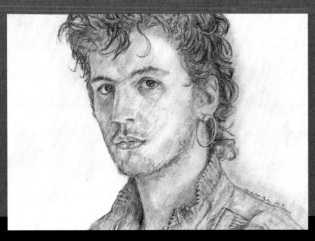

For the rest of the year, I was writing and editing the magazine article on the origins of COVID, which got longer and longer. I had a few days off in December, though, and I made three drawings. One was of a man with an earring. One of a girl in a hat. And

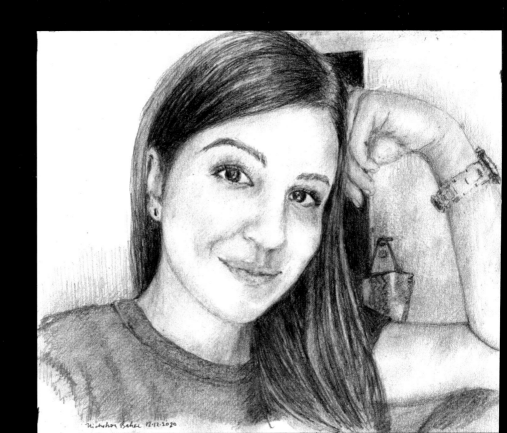

one of a woman sitting in her room, with her shiny bag hanging from a doorknob behind her.

The girl in the hat was possibly the best Reddit drawing I'd done. It was simple, but the texture of the straw hat was right, and the nobility of her expression came through.

I thought, I couldn't have drawn this drawing a year ago. And now I can. Progress.

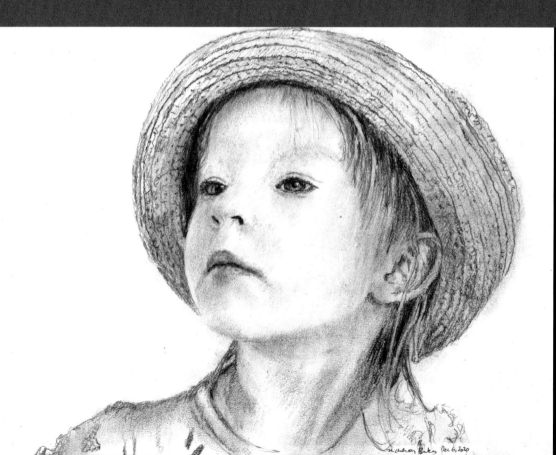

Late Middle

2021

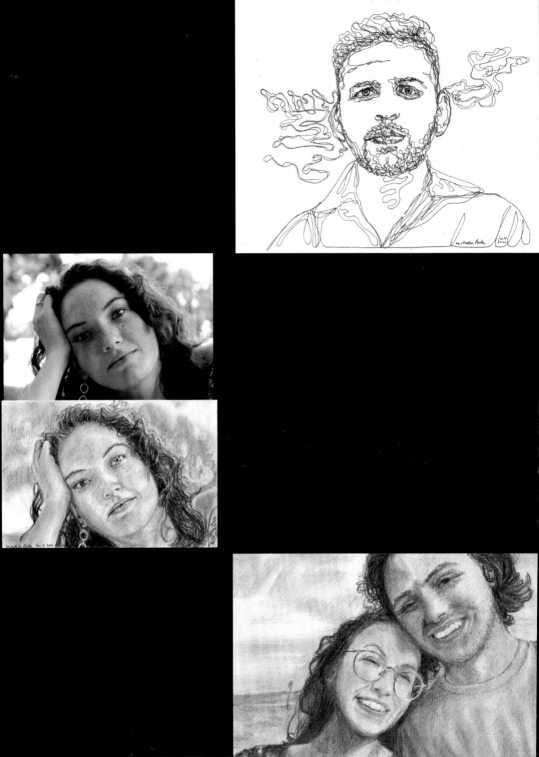

January 2021. This would be the year of color—that was my New Year's resolution. Maybe it wouldn't be the color of oil paints, or acrylic paint pens—maybe it would be pastels: loaves and lozenges and ingots of baked radiance that would stain my fingers and dust my optic nerve. M. had given me a beginner's set of pastel sticks for Christmas, along with a gradation of twelve grays. I still drew people on Reddit, couples and families and solo posters. But I began experimenting with pastels. I drew a new bride and a man with a beard. I had trouble with flesh tones, as I'd had with gouache and with paint pens.

There was something marvelously direct about pastel. It's finger painting: you smudge and blend it with your fingers. It's never sticky. It's dry from the beginning. No brushes needed. You just wipe your hands on your pants.

Here's the workflow I came up with. I made a pencil drawing—for instance, a drawing of my mother based on a selfie I'd taken with her. Not

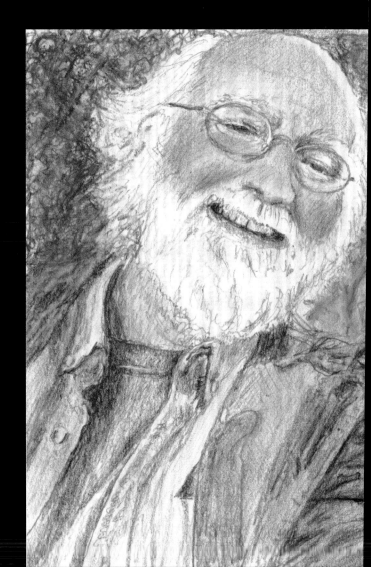

wanting to wreck the pencil drawing by covering it with layers of pastel, I scanned it and printed it out on matte paper—Epson double-sided matte paper or, later, watercolor paper or Pastelmat pastel paper. Then I drew over the printout with pastels. So I ended up with two separate works, a pencil version and a pastel-over-printout version.

I did this a lot on Reddit: scanned a pencil drawing, printed it out, pasteled over it—struggling as always with flesh tones. Sometimes, often, the pencil version was better than the color version. Sometimes I printed the drawing out several times and did color variations.

Turns out this pastel-on-a-monochrome-printout method is not so far from some of Edgar Degas's practices. He sometimes traced a photograph, flipped the paper over, and traced the tracing through an ink layer onto a metal plate, which he then used to

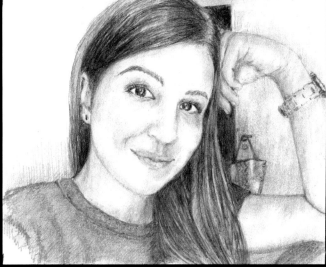

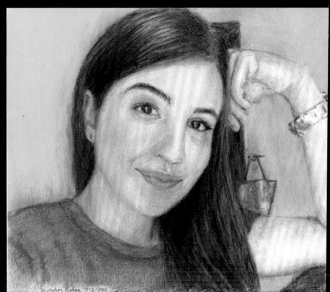

make one or more monotype prints. The prints he colored with pastels. Or he traced a photo, or an earlier drawing (of a ballet rehearsal, for instance), and then he had his framer, Père Lézin, glue the traced image onto a board, and then again he would go to work with his pastel sticks, crosshatching one color over another and spritzing fixative so that it would hold together. His method was "tracings of tracings," wrote his friend and dealer, Ambroise Vollard. In his case, the result was genius.

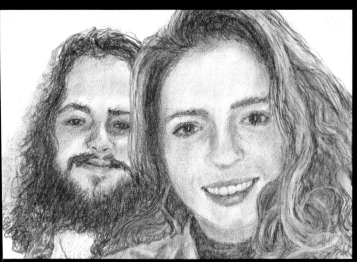

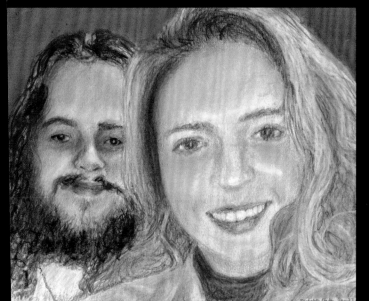

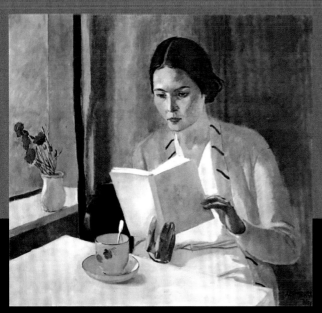

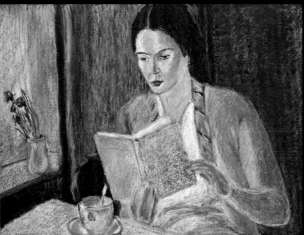

Aleksandr Deyneka, *Visit to the Museum*

I copied a painting from the 1930s by Aleksandr Deyneka, *Girl with a Book*. Deyneka was a Soviet realist, painter of athletes and factories and red flowers and red walls. His mosaic designs are in Moscow subway stations.

I copied one of Gustave Baumann's woodblock prints, studying how Baumann made the light gild the trees. For this exercise, I made a larger tracing on a flat-screen TV arranged faceup on boxes. Then I photographed the tracing and printed it out.

Gustave Baumann,
Pines Grand Canyon

For Valentine's Day I drew some carnations for M., using pastels and watercolor crayons. Some soft pastels are fairly hard, and some are ideally soft, and some are so fragile that they slump into gorgeous rubble as soon as they make contact with paper. The harder, chalkier ones tend to be cheaper, and they're very useful for drawing outlines and for filling large areas without taking up too much space in the paper's tooth. Some of the very expensive soft sticks have a stony, scratchy old-school quality, too, which grows on you—it's nice to crunch in a pale blue sky, crushing the crystals with your thumb—and some, the buttery ones, are made of pigment, talc, clay, and a touch of chalk milled to the fineness of pancake mix.

Tastiest pastel samplers—landscape,
from Rochester Art Supply

Because each brand has its own personality, I ordered some assortments from Rochester Art Supply, aka fineartstore.com: "13 Tastiest Pastel Samplers—landscape," and "13 Tastiest Pastel Samplers—lights." There were eraser-sized chunks by Diane Townsend, and cigar-sized blunts from Mount Vision Pastel Company, blocks of artful Gruyère from Great American Art Works, plus some Schminckes (the super-expensive legendary German brand) and some Senneliers and some Unisons, and others I forget. Each box arrived tied with string, like artisanal chocolates.

In the end I followed the example of Emma Colbert, a kind-voiced YouTube authority on animal portraiture.

Colbert lives in the south of Spain and sells pet portraits all over the world. I watched her paint a perfect owl using Unison Pastels—for which company she is now a brand ambassador—on Pastelmat paper. I listened to the patient, light, scrape-tapping sound as she smoothed in the feathers. I watched her paint a portrait of her own rescue cat, Mocha. I loved how she created the cat's marbled green eye using pastel sticks and pastel pencils, and how she whisked in the whiskers.

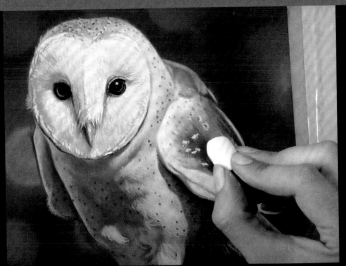
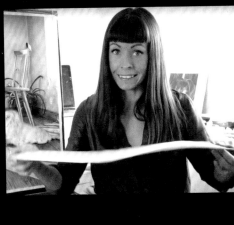

I ordered a set of Unison half sticks, made by a small team of hand-rollers in Northumberland National Park, not far from Hadrian's Wall. And a bunch of pastel pencils, including ones by Caran d'Ache, a Swiss company whose pencils can cover like pastel sticks but are sharpenable like pencils.

Pastelmat paper, made by Clairfontaine in France, offers a surface coating of cellulose fibers that seems to have conquered the fourth dimension: you can go over it with layer after layer of color, darks over lights, lights over darks, and it never becomes saturated. It's not as soft-focus as velvet paper, which Emma Colbert also uses, and it doesn't tear up your fingertips when you blend colors the way sandpaper does.

But sandpaper is interesting too. Karen Margulis, another much-watched pastelist on YouTube, uses ultra-fancy Terry Ludwig pastels, and she uses them on UArt "sanded paper." With quick jabs of pigment against the rough paper, she's able to slash and dash out effortless fields of wildflowers, while she explains her artistic decisions on the fly. I watched her video "Have You Tried a Baby Wipe Underpainting with Pastels?" in which in half an hour she narrates her journey through the unpromising, alcohol-scrubbed, downright ugly phase of the swabbed underpainting, and brings us safely to the final outcome—a windblown, arms-thrown-wide, poppy-sprinkled hillside. (The alcohol in

Karen Margulis

Karen Margulis, *Poppies*

the baby wipe dissolves and blends the pastel strokes.) One commenter wrote: "About halfway through I was kind of holding my breath, thinking OMG what a mess, it's not going to work, etc. But with every new addition of colour the painting took shape. Magical. I'm a fan now."

When I see Margulis or one of the other spirited pastel performance artists on YouTube—Marla Baggetta or Susan Jenkins of Monet Café—I feel kind of sorry for hardworking, brush-slapping Bob Ross, and his happy fan brush of a teacher, Bill Alexander. These woman have new moves.

Karen Margulis,
The Lazy Days of Summer

Forest Trees

Inspired by Emma Colbert, I made a copy of a landscape painting by Félix Vallotton (1865–1925), *Evening on the Loire*. I got excited by the buffalo parade of trees, the long purply shadows, and the lemon sky.

Inspired by Karen Margulis, I made my first born-pastel painting—meaning I didn't make a pencil sketch

Félix Vallotton, *Evening on the Loire*

beforehand—and I drew it on UArt sanded paper. My image was a backlit autumnal tree near where we live. I had a teaching fellowship at Colby College that semester, and after I took a COVID test at the cafeteria, I sat in my office for office hours (nobody came), and I drew the tree, by eye, no tracing, looking at the photo on my phone. My desk was covered with orange dust.

UArt sanded paper is real sandpaper—it drags and scrapes every screaming particle of saturated color off the stick. It makes chalk bleed beauty. You could sand a salad bowl in high school shop class with UArt paper.

LA PARESSE

Félix Vallotton, Swiss-born, was a friend of Édouard Vuillard, and like Vuillard he had a feel for patterns. He made elegant black-and-white woodblock prints and crisp still-life paintings. Late in life he painted one imperturbably surreal landscape after another.

"Life is a wisp of smoke," Vallotton wrote in his diary on December 22, 1921, "you argue, you submit to illusions, you clutch at phantoms that dissolve in your hand, and then death is here." He died in 1925, just after he turned sixty.

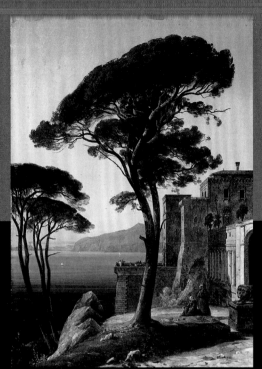

I learned the cardinal rule of tree branches. The rule is that no branch ever gets thicker toward the end. It always, always tapers, except that it sometimes gets knobby at a place of juncture, where it splits. I mused on this rule, which I had failed to follow, as I copied a graceful tree in a painting by August Ahlborn, *Monastery on the Gulf of Naples*.

When you make your own art, however flawed it is, other people's art becomes more graspable, more approachably alive. When you copy other people's art, and devote your full mind to reproducing it, you learn things without knowing that you're learning them, some of them beyond speech, but nonetheless knowable.

People were starting to get vaccinated. The pandemic was going to be all over soon, we thought.

I drew a mother, a daughter, and a granddaughter from Reddit lifting their glasses in a celebratory toast.

LEARN ALL THE SKILLS
YOU NEED TO BECOME

MORE VIDEOS

"Urban Sketching
for Beginners,"
at ianfennelly.co.uk

Urban Sketch Course's Virtual World Sketching Tour By Ian Fennelly

Watch later Share

"Urban Sketch Course's
Virtual World Sketching
Tour by Ian Fennelly,"
YouTube

AN EXCITING NEW COURSE

0:10 / 0:58

YouTube

On sketchbookskool.com I found an ink drawing of a street in Puglia by the irrepressible Ian Fennelly, who sketchbooks his way around England and Venice and Route 66 and many other places. I copied his drawing, and learned eighty-seven things about stones. Thought about nothing but stones for an hour and a half. Wanted to think more about stones.

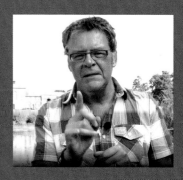

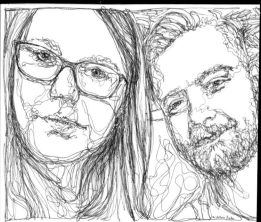

Whenever I started to forget how to draw
faces, I went back to Rcddit and found
someone who was asking for a portrait.
I bought a set of charcoal pencils from
General Pencil and tried out the browns—
burnt sienna and burnt umber and sepia.

April 2021. I added a hint of pastel color to a drawing of M.'s hands on one of our dogs. And drew her in a ribbed sweater. The thing about drawing someone you love is that you have a chance to think uninterruptedly about the nature of your love and the details of your love.

And—why not?—I drew a rabbit, from a stock photo, using a tightened loop technique to make the fur.

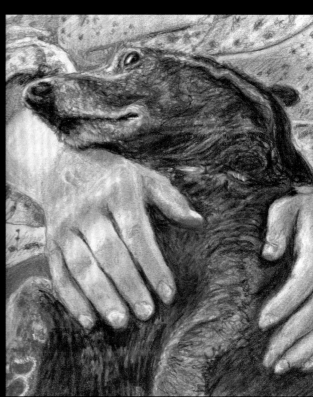

There's a guardrail at the end of our street. I took a picture of it and re-created it. I finger-painted the sky, making the colors slide from Naples yellow through almost green to blue. Satisfyingly messy on my fingers, but clean on the paper. I noticed that leaves that are invisible against the sky are visible against the far bank of the river.

Some people brood over what fixative to use. I brooded myself until I read and watched a lot of reviews. Now I use Spectrafix. Spectrafix is made of casein (a

 milk protein)—plus water and alcohol. It deals gently with colors, doesn't destroy your lungs, has no aerosol propellant because it's a push spray, and is supposedly based on Degas's preferred formula: "Made from an antique recipe used by French artist Edgar Degas in the 1800's." All fixatives dull pastel's crystalline glitter a little bit, but that's not necessarily a bad thing. It ties the surface together. Spray and enjoy.

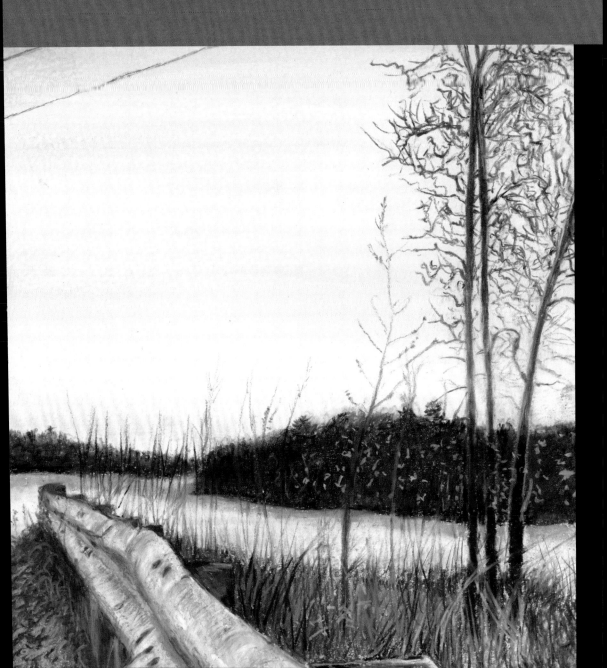

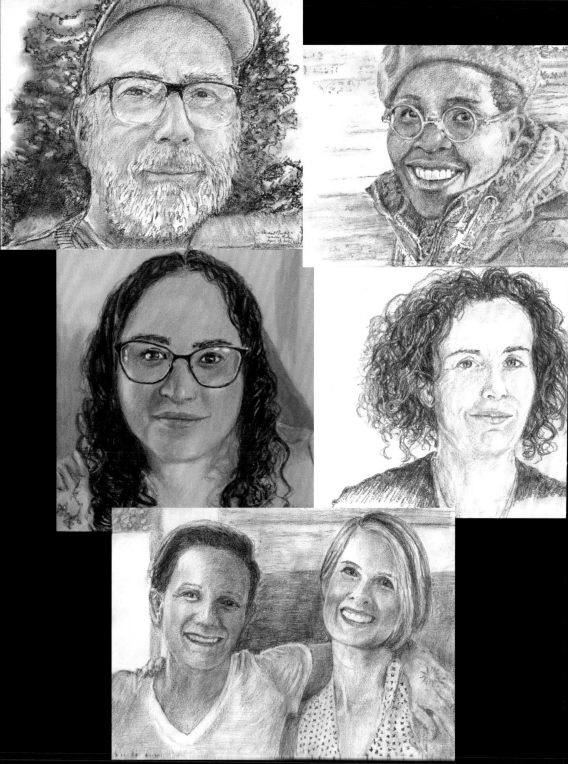

I sent out an email to the Colby College English Department saying that I was working on a book about learning to draw and paint on the far side of sixty, and that I would draw anyone's portrait who wanted to be drawn. About a dozen photos came in from faculty, staff, and students.

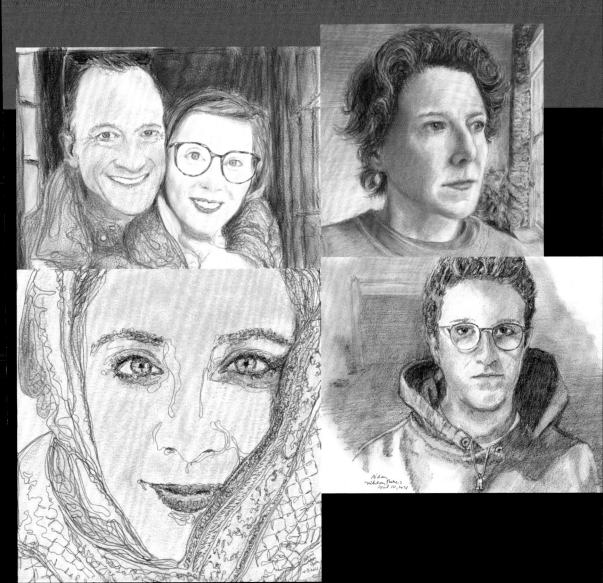

I wandered around Waterville taking pictures. There was a red record store and its shadow on Main Street. The Colby College Library, where the English Department was, glowed in the early evening. It didn't glow quite as much as I needed it to in my pastel version, so I slid Photoshop's level sliders to the right a little until the almost black parts of the lawn were almost black.

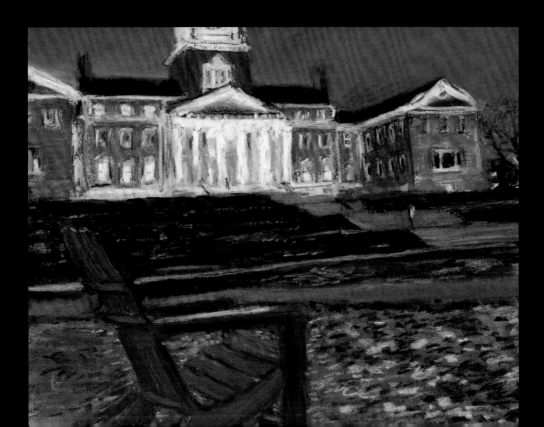

On a bike ride one morning I stopped in front of two houses, one in need of paint. Another time I paused to take a picture of the road along the river. It seemed like all of central Maine was crying out to be put on paper. The road I drew on Art Spectrum Colourfix sanded paper. I was worried, printing out the pencil undersketch, that the sanded surface would destroy the print heads in my printer, but it didn't.

In my "To Paint" folder, I found the photo of M. in the Colby Museum and made a pastel version of it, working some greens and blues into the shiny floor. The floor of my drawing was cream-colored Pastelmat paper. The hardest thing was the picture frame.

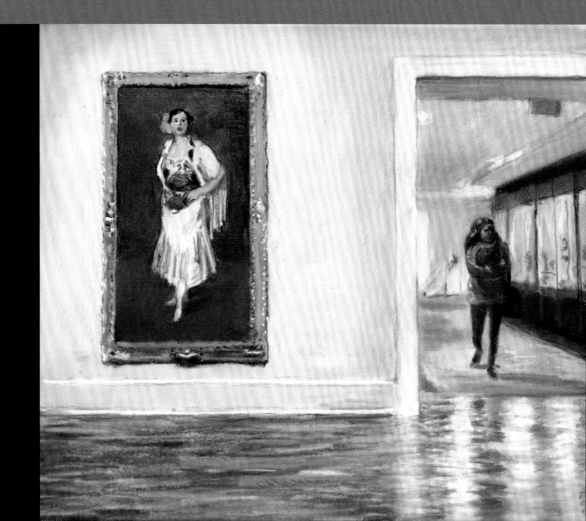

I drew my wife some more times.
Every time I drew her, I smiled.

Also I had a feeling that I was ready now to try doing some portraits of our children, Alice and Elias. The stakes are very high with your own children: you know exactly what they look like, and you really, really don't want to fail. When you first trace them, they seem for a moment like strangers—like plaster casts. Then, when

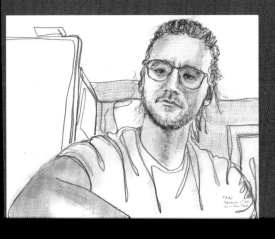

you begin to shade in their likenesses, it's amazing how the past wells up. Every parent should try this. It's a new way of experiencing love.

One of my drawings of Elias is from when he was seven, holding one of his complicated LEGO creations.

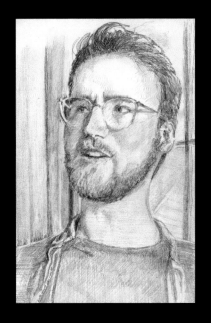

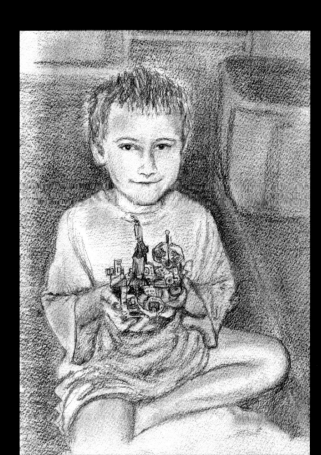

I watched two courses on Domestika. Each cost less than twenty dollars; both were incredibly helpful. Alex Hillkurtz taught architectural sketching, guiding us through the painting of a café in Paris with a red awning. He said he had taught himself to draw as a boy by copying storyboard art by Joe Johnston of *Star Wars* spaceships.

Mattias Adolfsson, a Swedish sketcher, showed how to do a drawing of his own messy office in ink, cartoonizing

it and then coloring it in with watercolor. After watching Adolfsson work, I made three ink-and-watercolor sketches: one of Adolfsson himself, one of a family of four from Reddit, and one of a snowy street in Waterville that had looked so gorgeously unremarkable when I drove past it that I had to stop, roll down my window, and take a picture.

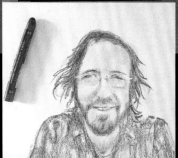

May 2021. My friend and former student Danny Arsenault, who has a podcast called *No Reason to Exist*, is a pencil collector. He mailed me several unusual pencils when I told him I was doing drawings. I used one of them, a Lyra 6B graphite stick with no point, to draw him.

The Lyra pencil forced me to be a bit looser: I also used it to draw a close-up of Robert Henri's Spanish dancer. Then I added some color with watercolor crayon.

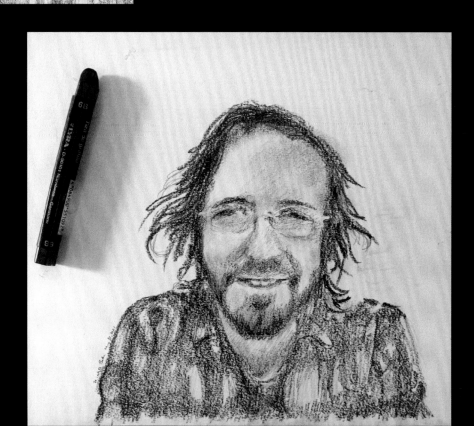

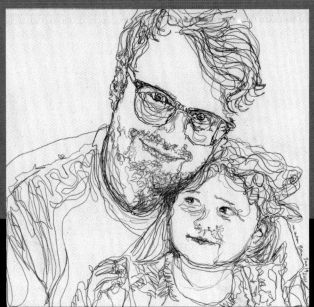

June 2021. I kept thinking about smiles—how many kinds there are, how face-transformingly beautiful they can be. There are smiles of adoration, celebratory smiles, knowing smiles, serious smiles, dubious smiles, uncontrollable smiles, modest smiles, smiles of curiosity—on and on. Shades

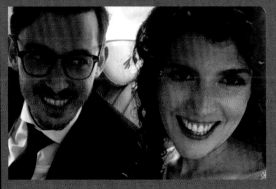

and subtleties of smile innumerable. Smiles are a major part of being human, obviously. They involve the whole face. And the arms and hands as well, sometimes. And yet in the history of art, the smile, especially the open smile, is fairly rare, except in depictions of drunken carousers, lute players, and other relaxed folk. And in Dutch paintings.

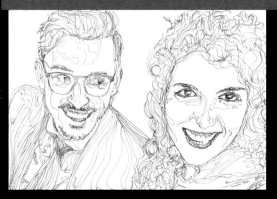

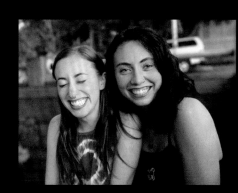

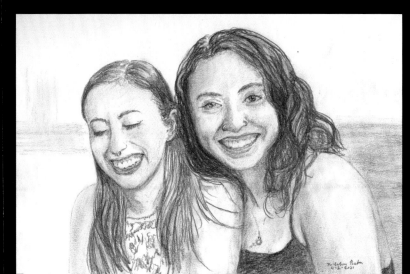

John Singer Sargent, *Rose-Marie Ormond*

Portrait of Ena Wertheimer

Italian with a Rope

Portrait of Mrs. Charles Hunter

There's a good book on the history of the smile by Angus Trumble, former director of Australia's National Portrait Gallery, and a good essay by Nicholas Jeeves, "The Serious and the Smirk." "In the long history of portraiture the open smile has been largely, as it were, frowned upon," Jeeves writes.

Which is one of the many reasons why I like John Singer Sargent. Influenced perhaps by candid photographs with early Kodak cameras, he painted several kinds of smiles. And not just closed-mouth smiles—full-on, teeth-showing, affectionate, human smiles. Mary Cassatt did, too, sometimes.

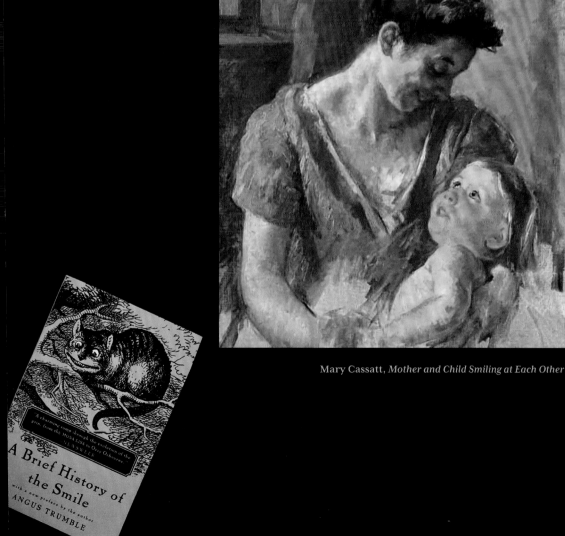

Mary Cassatt, *Mother and Child Smiling at Each Other*

Occasionally, as I posted more drawings of strangers on Reddit, I wondered whether I should be drawing faces from life. I immediately thought: No, not yet, anyway. I'd rather make my mistakes in private.

Also, I'm interested in real facial expressions. Amusement, high spirits, ruefulness, triumph, nostalgia, uncertainty, regret—fleeting emotions. A camera can catch and hold a state of feeling as it lives on a face for as long as it takes to draw it. But no model, no sitter for a portrait, can hold any sort of genuine, subtle expression for more than a moment. Within seconds, it evaporates or becomes a fake, exaggerated version of

itself. Everyone knows this. The fleetingness of authentic emotion explains why so many heads painted or drawn from life by fantastically accomplished painters show faces that are vacant, mildly stunned with boredom, remote, drained of personality, staring zombielike into the middle distance.

If you're a genius like Sargent, with a freeze-frame visual memory, you can make a charcoal sketch while you're having a chat with your sitter, and thereby end up with a living, glowing portrait, full of personality. Otherwise, you're going to need photographs, or screenshots from a movie.

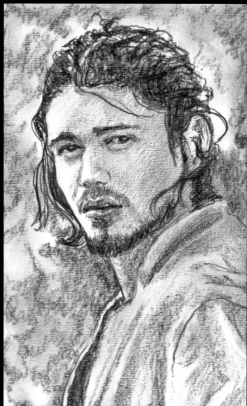

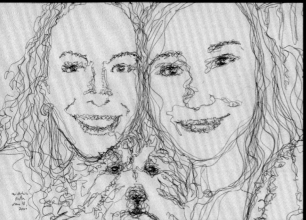

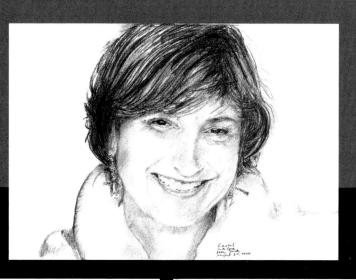

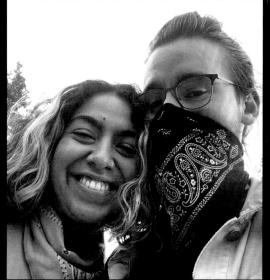

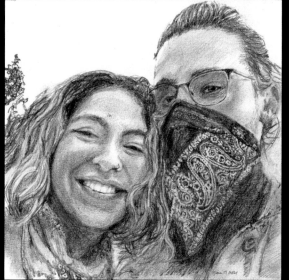

I drew more family. My son with his partner, Izamar. My sister, Rachel. My father and my father's partner, Janice, with me in a selfie.

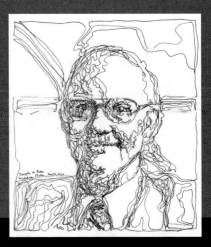

This sketch is from a photo of my sister and me hamming it up in a photo booth

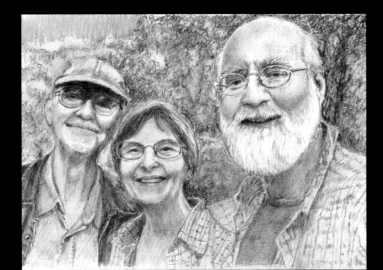

July 2021. I used a water sprayer on inkjet prints of some
of my scanned pencil drawings. The water dissolved
the inkjet ink, creating interesting effects, and then I
scanned the spritzed, blotched pages and added layers of
color in Clip Studio and Photoshop. I also tested a blue
watercolor wash on Ingrid Bergman and made some
self-portraits. The yellowy green one is me after I've
spent too many years writing about the Cold War.

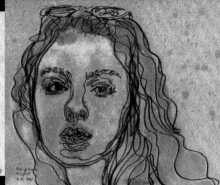

After a photograph by
Omid Armin on Unsplash

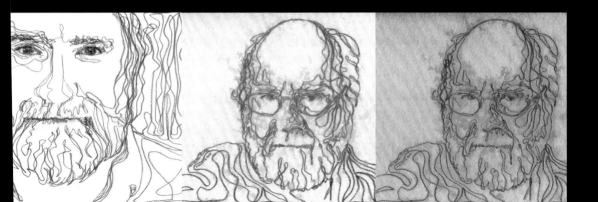

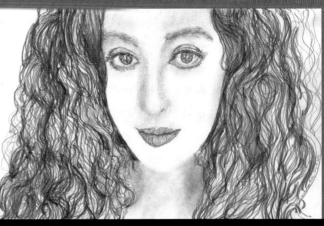

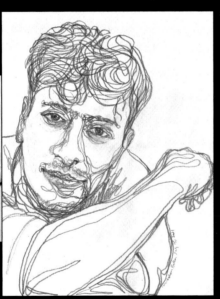
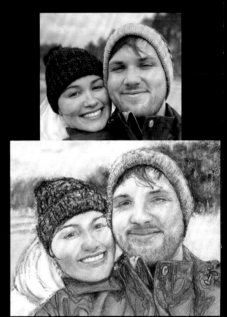

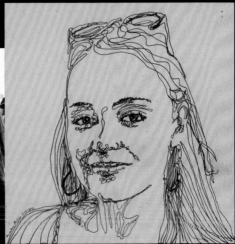

Every few days I would check into Reddit and find
people whom nobody had drawn, and I'd reach
for a pencil or a pen. I couldn't keep away, even
though I knew it was obviously a way of putting
off what I was supposed to be doing, which was
writing a book about learning to paint. I drew
in ballpoint pen, in pencil, and in soft graphite
sticks—sometimes adding color with pastel or
watercolor or Clip Studio.

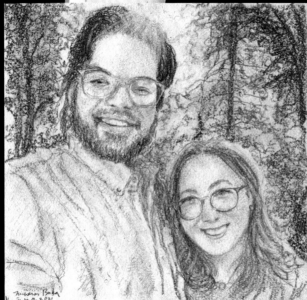

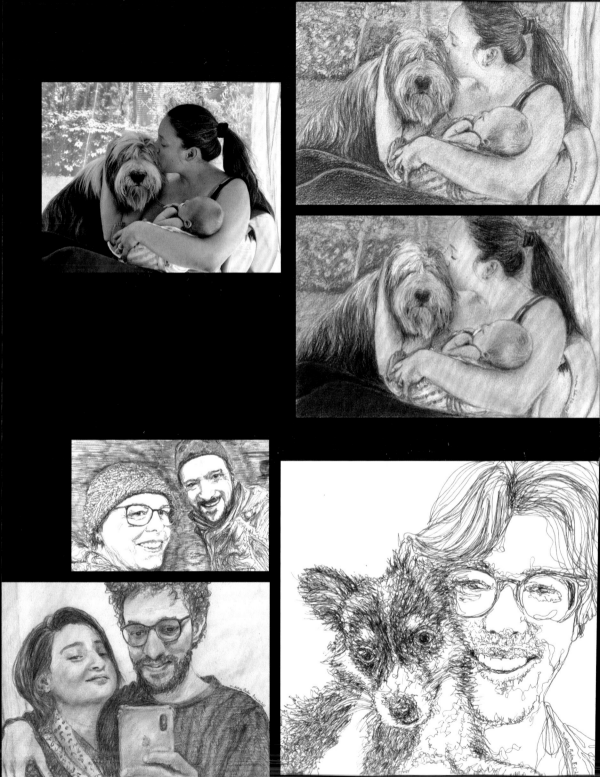

More underdrawn Redditors, including a woman cradling her baby and her dog, and another woman whose dog's ear was inside out.

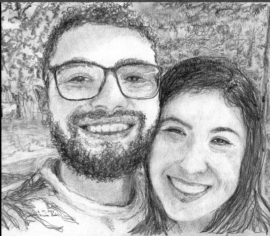

August 2021. I called up John Whalley, an artist from Damariscotta, Maine, who draws large finely detailed pencil drawings and makes hyperrealistic paintings using egg tempera. *Cow Pond*, a three-foot-wide graphite astonishment, took him weeks of pencilwork, but the one that really tested his stamina was *Winter Field* (2020), which is 43 inches of glorious

corn stubble. Whalley, who has lived through two types of lymphoma and a stem cell replacement, is interested in old tools—old screwdrivers and awls, for instance. He has a large collection of brass nozzles, several of which he's painted and drawn. After I drew Whalley (from a video screenshot), I used a brown pen to copy a detail from one of his nozzle paintings. He told me he reads a bit of the Bible every morning

Dina Brodsky, artist of trees and birds, announced that she was teaching another "Instagram for Artists" seminar, so I signed up. Brodsky explained that actually nobody, not even senior engineers at Instagram, fully understood how Instagram's algorithm operated, pushed and pulled as it was by so many variables. Even so, "dwell time"—the time that people lingered over one of your posts, was all important. The number of likes you got for a given post, on the other hand, was less important. Meanwhile, the TikTok tidal wave was rising.

The important thing, according to Brodsky, was to bring people into your artistic process, and that meant making little movies. One of Brodsky's movies shows her drawing a tree in a park, and then she turns her phone to show that her son is next to her drawing the same tree.

She has half a million followers. And she does beautiful work.

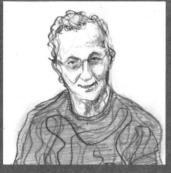

Because Dina Brodsky is a generous praiser of other artists, I learned about Frederick Brosen, painter of New York streetscapes.

Brosen begins with a super-detailed pencil drawing, say of Broadway and Grand Street after a rain, done with a hard 6H pencil, and then he adds layers of watercolor until the scene shines.

He illustrated a book called *Still New York*. Every page is a revelation.

I took a two-hour Zoom class with him. He told me that once every five years he visits the Mauritshuis museum in The Hague, stands before Vermeer's *View of Delft*, and cries because it's so good.

After the Zoom class I made two drawings of Brosen, one of him spinning a basketball and one not. He's proud of his biceps.

Brosen has had twenty one-man shows, but he says the gallery system doesn't work very well anymore. He teaches and he posts things on Instagram. One of his regular students is talk-show host Howard Stern.

September 2021. I chanced upon an Australian artist, Judy Drew, and ordered a postcard-sized book from her entitled *Expression Through Colour*. Her pastel surfaces grow out of darkness but they are feathered and fidgeting with color, sometimes almost squirming with color—golds and yellows and reds on Canson sanded paper. She emailed me that she took to the rougher paper texture right away. "The sanded paper has a good 'tooth' and so allows lots of build up of the pastel when alternated with light sprays of fixative," she said.

Judy Drew, *La Parisienne*

Drew works from life, not from photographs. "I need the model to keep still and I sit very close and examine their face. It must be unnerving for the model but most people begin to relax over time." For years she's been a collector of fabrics, which she uses in her art. I asked her if it helped to know the person that she's painting. No, she said, it didn't make much difference. "I'm simply putting down on paper what I see in front of me as sensitively as I can." Degas's technique, she wrote me, captures her heart.

Out of curiosity, I looked up several lists of best living Australian artists. Nobody on those lists was anywhere near as good as Judy Drew.

I woke up with Sade's music in my head, and I drew a copy in pencil of the photo by Albert Watson on the *Best of Sade* CD cover, as close to it as I could make it. I used the blunt Lyra 6B pencil for her hair.

Blue pen seemed right to use for a second glimpse of Sade, drawn from a frame of a music video. I posted the drawings on Instagram.

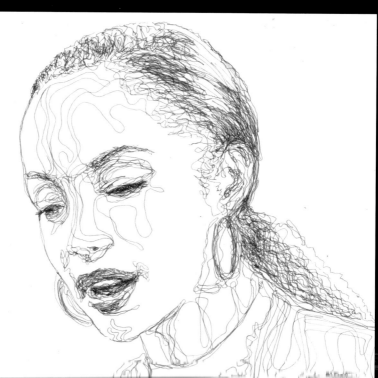

It also seemed important to draw a Swingline stapler I've owned for a long time, first in pen and then with pastels. Which led me to draw Jack Linsky, inventor of the Swingline stapler. I used a wiry sort of style, as if all the world was made of bent staples.

I took a picture of a china doorknob in our house, with light coming through the blinds, and I thought, I'd like to paint this. I spent a day making a pencil drawing, which then sat in a pile for several weeks. Then I scanned it, printed it out on thick paper, and colored it in using watercolor and pastel.

Making my own coloring book.

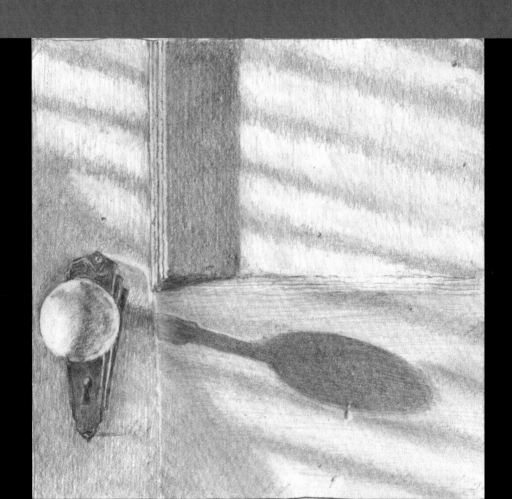

Some art teachers say they never use black, only dark blues or deep browns. But Félix Vallotton, in a painting I came across of a woman reading, seemed to be using

Félix Vallotton, *Woman Reading*

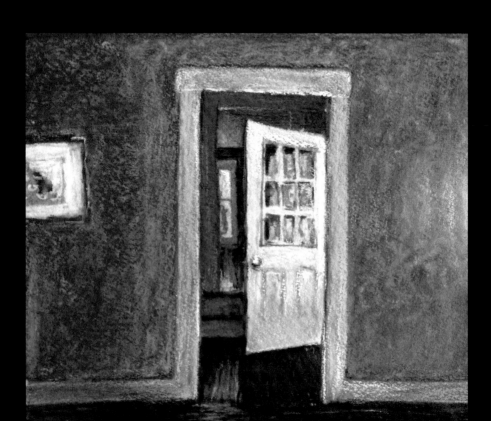

black right out of the tube. I copied it, interested by the deco robe and the extreme paisley wallpaper.

 I made a pastel drawing of an empty house in Orono with an open front door. When I posted it on Instagram, someone said that it looked gloomy and sickly. Which was true.

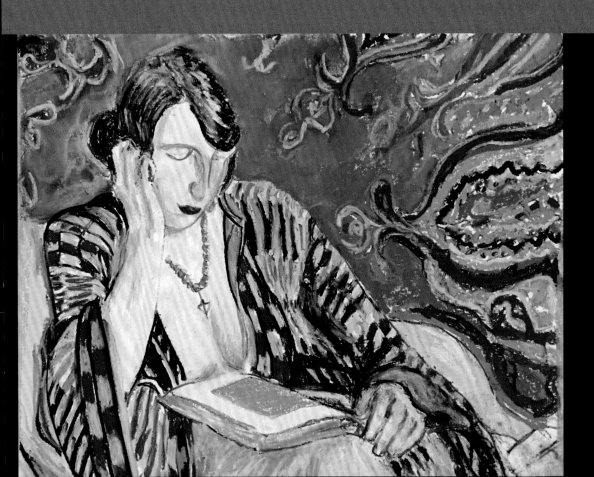

I added some surrealistic color to my drawing of René Magritte and Georgette
Berger. Then made a mini movie of the color changes and posted it on Instagram.
And immediately regretted it. I began to get an uncomfortable feeling that
Instagram wasn't for me.

I began overclocking—constantly asking myself, What should I be drawing for Instagram today? How can I tease and please the algorithm by making nifty little process movies? I filmed my hand holding a pencil and touching up an eyebrow in a Reddit portrait. Fortunately, something kept me from posting the film.

I did post a pastel version of "Woman Whose Dog's Ear Is Inside Out," however, and I posted a portrait of Vilhelm Hammershøi, painter of empty Danish rooms, as a young man. I liked that he had a bit of a smile.

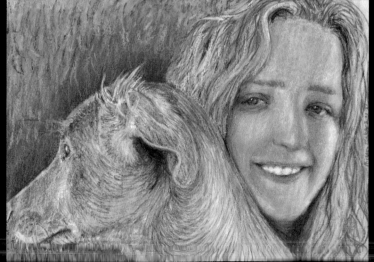

My last Instagram post was a mini movie of photorealist Richard Estes standing in front of one of his paintings, to which I had added some entirely unnecessary color manipulations and substitutions in Photoshop. Shortly after that, I deleted the movie and some other posts and wrote in my bio that I was on break. Instagram is (for me) too distracting, too addictive. More so than Twitter, even. And I was already on a Twitter break.

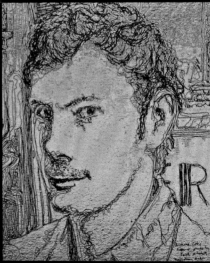

The first time I saw a Richard Estes painting in person was at the Portland Museum of Art in 2014, as part of a show billed as "the most comprehensive exhibition of Estes's paintings ever organized." Estes's moment of breakthrough came somewhere around 1966, when he painted the reflection of a green bus, and a single passenger, in the blue paint of a car's trunk, in *Bus with Reflection of the Flatiron Building*. It's a remarkable

work—but the painting that left me speechless, rooted to the spot, was *Jone's Diner*, from 1979. Angled sunlight, a bit of litter at the opening of the storm sewer. No traffic. Perhaps it's a Sunday morning.

Jone's Diner is gone, torn down, but that perfect nowhere-in-particular corner lives on in the blue sky of Estes's art. And Estes himself is still alive—he lives only about an hour away, on Mount Desert Island. Why do I not call him?

October 2021. I pasteled a drawing of the living room of our former house on the day we moved out in October 2017. Scumbling in the pale blue reflections in the floor, tapping them with a fingertip to dull them down a little, I remembered the wide, undulating floorboards of that room. I'd written a whole book sitting in front of that fireplace. Goodbye, house, and thank you. You were expensive to heat, but you kept us dry.

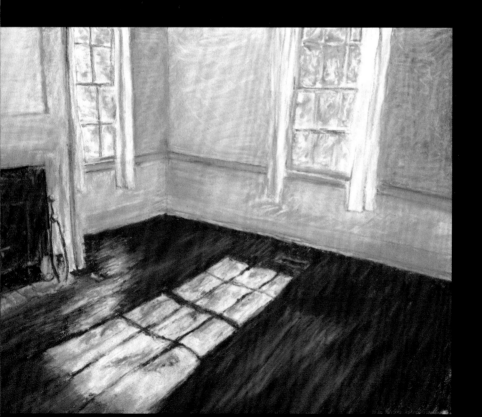

I also made a pastel pencil study of downtown Bangor, with its new sign "Calling All Creative People." The sign was painted by Annette Dodd, owner of Bangor's Rock and Art Shop, which sells polished stones in little baskets, sorted by color, with handwritten explanatory labels.

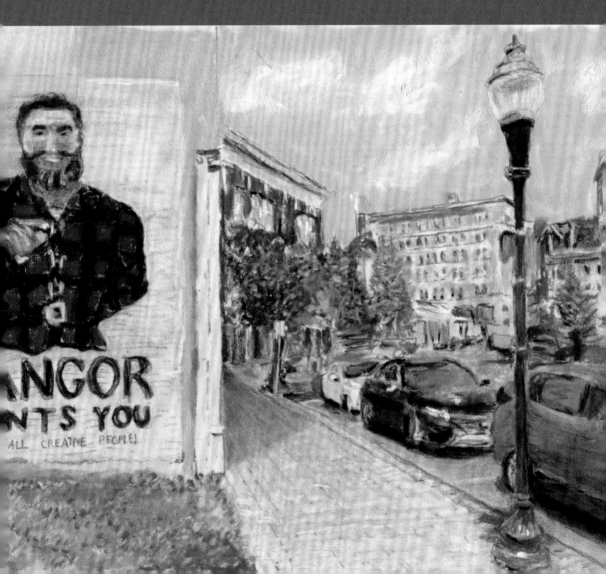

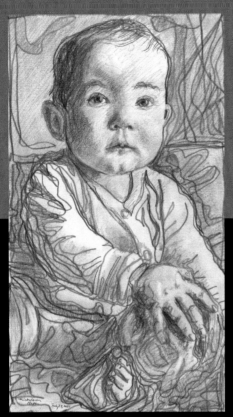

November 2021. The next phase was digital. I bought a used iPad from my son and learned Procreate, which is a wildly popular art-making app created in Tasmania. Procreate is all about layers and brushes. The brushes are not really brushes, though, because they're controlled by a white battery-powered device, the Apple pencil. To get rolling, I took two Procreate courses from animal painter Román García Mora on Domestika and watched a lot of YouTube.

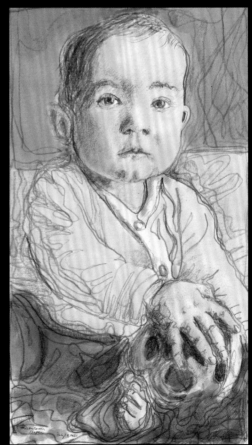

Procreate made it possible to paint with a pencil. I
didn't have to mix the paint, either—I just had to choose
a color on a color wheel. That was huge. I could paint
sitting in the car, or even lying on my side in bed.

I still started with a scan of a real sketch, though—
made with real pens or pencils. I'd learned how to
paint with Procreate, but oddly enough I couldn't draw
with it.

I downloaded a set of digital watercolor brushes and used them in Procreate to make some experimental out-of-focus backgrounds (somewhat cheesy, I now see). I even tried out a pack of John Singer Sargent digital brushes. I did a few more pencil drawings, and then I suddenly understood that I had to stop Reddit too. And at least pause Procreate.

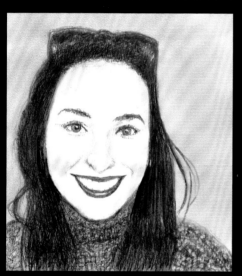

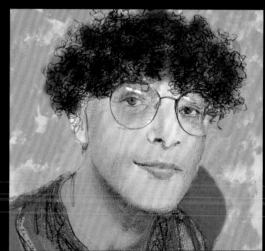

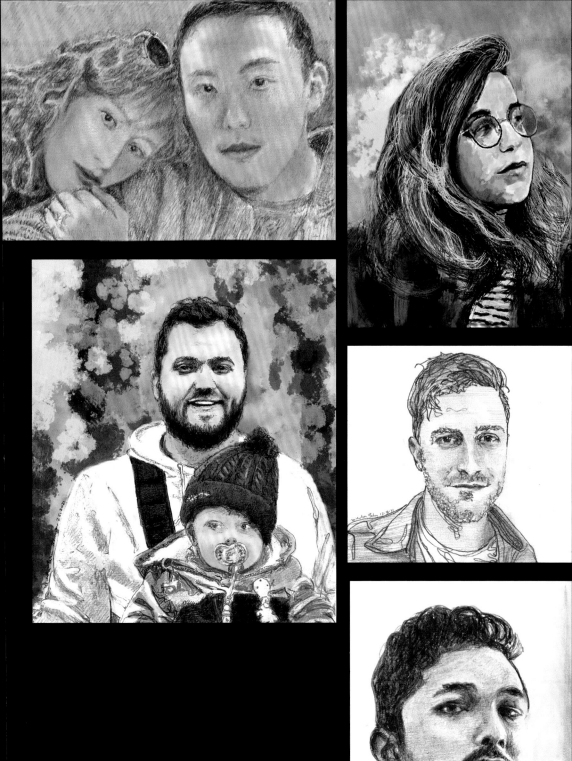

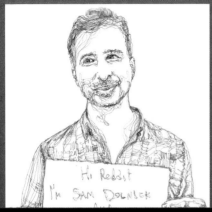

Sam Dolnick

December 2021. No more excuses. I'd tried oils, tried watercolors, knew how to get around Procreate, and had gotten fairly deep into pastels and pencils and pens. And now I was off Instagram, off Twitter, and off Reddit. I had plenty of notes. It was time to write

Sam Husseini

Edward Hooper

Ben Dolnick

the book—the book that was supposed to be about learning (or not learning) to paint dappled shade.

Instead of writing the book, I drew writers. Drawing writers was a handy way of putting off writing. As soon as I began sketching, usually at the person's right eye, I felt a quietness and a surge of attentive committedness that I didn't feel when I was writing about drawing.

Agatha Christie, circa 1925

Kurt Vonnegut and Jill Krementz, after a photo by Saul Leiter

Rachel Carson, after a photo by
Alfred Eisenstaedt

Thomas Steinfeld

Gary Shteyngart, after a photo by Ramin Talaie

Instead of painting, I drew painters
I hadn't yet drawn. James McNeill Whistler,
Cecilia Beaux, Gustav Klimt, Mary Cassatt,
Gretchen Dow Simpson, and Carole Rabe.
Also Degas and Vallotton in soft hats.

More painters, and teachers, and explainers—Mark Carder, Karen O'Neil, Patti Mollica, and Carol Marine. Andrew Tischler and Dmitry Volegov from the world of YouTube. Lena Rivo, of "Color Mastery." And Colin Page, who taught me about skyholes and vibrating color.

Here are some things I've learned over two years of drawing.

(1) Drawing is knowing.
(2) There are many living artists who are doing beautiful work. We may be in the midst of a revolution of taste.

(3) The human face is an infinitely variable, one-of-a-kind, telekinetic marvel.

(4) Smiles are hard to get right, but are worth trying.

(5) Everyone has some festive corner in the funhouse of their soul.

(6) It's enjoyable to draw wool hats and wavy hair.

(7) Drawing feels private, intimate, autobiographical. Painting feels public.

(8) There's nothing like seeing a recognizable pair of eyes become real on the page, looking directly at you, made out of silvery dust.

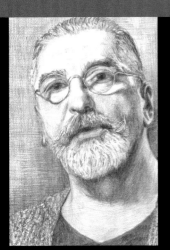

And I've learned that the kind of art I like to do is basically a way of saying thank you without having to say it in words. Thank you to artists and writers and singers and good-deed doers. And to clouds and trees and parking lots and houses and towns. And to my family. And to plastic windup eyeballs that hop around on the desk.

A windup plastic eyeball with two broken toes has been in my life for about fifteen years. I've wanted to say thank you to it by drawing it.

First I thought of tracing it. Then I thought, No, I don't want to trace an eyeball. I stood it on a piece of paper and drew it from life, by eye. Not looking at the photograph. I eyeballed the eyeball.

Strange fact: After two solid years of tracing, I'm better at drawing freehand. I didn't know this was happening—it just happened.

Ending

2022

January 2022. I'm finally finishing a draft of the book, and I'm wondering about something. The hopping eyeball was a simple set of shapes, mostly circles. The question is, Can I now also draw something more complicated without tracing it? Like, for instance, a face?

On January 13, 2022, I looked through a Dover book of Old Masters' drawings that my daughter had given me for my birthday, and I stopped at *Head of a Young Man*, by Andrea del Sarto. For the next hour, I eyeball-sketched it. No paper taped

to the screen, no grid lines, no crosshatched circles and ovals, no proportional divider—I just drew it.

A few days later, I did the same thing with Leonardo's study for *Madonna of the Rocks*—praised by Kenneth Clark as the most beautiful drawing in the world. (It is awfully good.) No tracing.

Both my copies have obvious mistakes, but both are at least in the ballpark. Conclusion: I'll still need to trace if I want to get a true likeness. But I'm moving in the right direction.

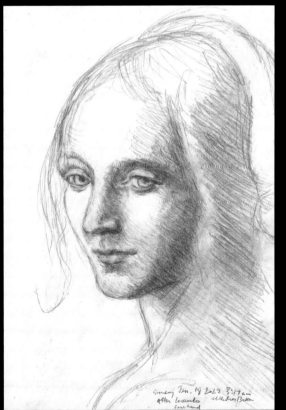

It's the end of January 2022, and right now it's negative 6 degrees outside. This morning I finally drew Adam Schlesinger of Fountains of Wayne, who died at the beginning of the pandemic, from a photograph by Violeta Alvarez on Shutterstock. My son and his partner, Izamar, have COVID, despite their vaccinations. But they're getting better.

I've finished a less insane version of the family of five on Reddit: pencil plus Procreate. I'll post it today. In the next month, I'm going to make some cloud and shadow and river paintings. I'm going to paint the bowl of cherries, if not with oil paints then with pastels. I feel ready now. If those paintings or others actually happen, I'll add them to this book.

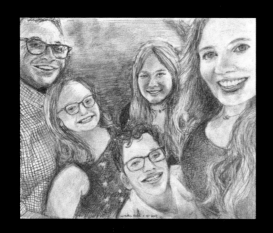

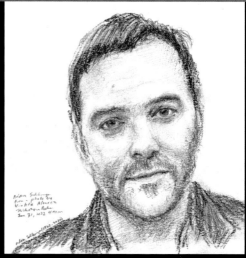

Adam Schlesinger

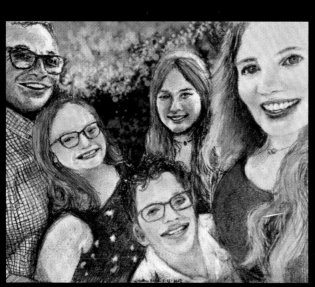

What I'd really like to do, though, when or if the world goes back to normal, is to learn how to paint people sitting on couches in their living rooms, or wherever they like to sit. And also, because there are so many artists doing good work right now, I'd like to start a museum. That probably won't happen, but it's fun to think about buying other people's art with other people's money.

Meanwhile, there's always pencil drawing. Just yesterday I finished another drawing of M. She's smiling, sitting in our kitchen. For some reason, her hand came out huge.

I think that's everything.

Envoi

Draw from life if you want. Draw from photographs if you want. Trace if you want. (But give credit to the photographer if you didn't take the picture.)

Draw your friends, draw your heroes, draw your family, draw the morsels of the world that mean something to you.

Find what's there.

Acknowledgments

I'm grateful to Ann Godoff, my editor,

and to my agent, Melanie Jackson,

both of whom encouraged me to get to work on this book.

Casey Denis and Victoria Lopez at Penguin Press saw the

manuscript through to publication with kindness and patience.

Claire Vaccaro is responsible for the beautiful design and page layouts.

Thanks and love as always go to my family—

all of them have helped me find

new ways of looking at life.

Image Credits

Unless otherwise stated, all images were provided courtesy of Nicholson Baker.

Page 1: *Baseless* by Nicholson Baker, 2020, Penguin Press. Designed by Stephanie Ross.

Page 11 (top): John Ruskin, *Water Lily Leaf*, via Lancaster University's Ruskin Library Catalogue

Page 11 (bottom): John Ruskin, *Finished Study of Agrimony Leaves*, 1875, via The Ashmolean Museum.

Pages 12–15: Margaret Brentano

Page 16: Henri Le Sidaner, *The Table in the Sun*, 1911, Nantes Museum of Arts, via Wikimedia Commons

Page 18 (top left): John Singer Sargent, *Fumée d'Ambre Gris (Smoke of Ambergris)*, 1880, Clark Art Institute

Page 18 (top right): John Singer Sargent, *Portrait of Helen Howe*, 1922

Page 18 (bottom left): John Singer Sargent, *Bedouins*, 1905–1906, Brooklyn Museum

Page 18 (bottom right): Mary Cassatt, *Young Mother Sewing*, 1900, Metropolitan Museum of Art

Page 19 (top): John Singer Sargent, *Corfu: Lights and Shadows*, 1909, Museum of Fine Arts Boston

Page 19 (bottom right): Mary Cassatt, *Portrait of a Young Woman in a Red Dress*, 1882, Private Collection

Page 19 (bottom right): Mary Cassatt, *Child in a Straw Hat*, c. 1886, National Gallery of Art

Page 20 (top): Édouard Vuillard, *Interieur*, 1899, via Wikimedia Commons

Page 20 (bottom): Edouard Vuillard, *The Dressmaker's Studio*, 1892, Private Collection

Page 21 (top): Gustav Klimt, *Birch Forest*, 1903, via Wikimedia Commons

Page 21 (bottom): Gustav Klimt, *Beech Grove I*, 1902, Galerie Neue Meister, via Wikimedia Commons

Page 26: Courtesy of Carol Marine

Page 27: Patti Mollica

Pages 28–29: Artwork by Mark Carder

Pages 30–31: Courtesy of Andrew Tischler

Pages 32–33: Vladimir Volegov

Pages 34–35: Artwork by Carole Rabe

Pages 36–37: Paintings © Karen O'Neil

Page 38 (top left): Zinaida Serebriakova, *At the Dressing-Table, Self-portrait*, 1909, Tretyakov Gallery, via Wikimedia Commons.

Page 38 (top right): Zinaida Serebriakova, *On the Beach*, 1927, via WikiArt

Page 38 (bottom): Zinaida Serebriakova, *Self-portrait*, via WikiArt

Page 39 (top): Zinaida Serebriakova, *Bather*, 1911, via Wikimedia Commons

Page 39 (bottom): Zinaida Serebriakova, *At Breakfast*, 1914, Tretyakov Galley, via Wikimedia Commons

Pages 40–41: Quang Ho

Page 42: Cecilia Beaux, *Man with the Cat (Henry Sturgis Drinker)*, 1898, Smithsonian American Art Museum, via Wikimedia Commons

Page 43: Cecilia Beaux, *A Little Girl*, 1887, Pennsylvania Academy of the Fine Arts

Page 44 (left): Cecilia Beaux, *Twilight Confidences*, 1888, Georgia Museum of Art, via Wikimedia Commons

Page 44 (right): Cecilia Beaux, *Ernesta (Child with Nurse)*, 1894, Metropolitan Museum of Art

Page 45 (center left): Cecilia Beaux, *Dorothea and Francesca (The Dancing Lesson)*, 1898, Art Institute Chicago

Page 45 (center right): Cecilia Beaux, *Ernesta*, 1914, Metropolitan Museum of Art, via Wikimedia Commons

Page 45 (bottom right): Cecilia Beaux, *On the Terrace*, via Hillsdale Collegian Archives

Pages 46–47, 55, 57: Paintings © Colin Page

Pages 68–69: James Gurney

Page 70 (left): Maxfield Parrish, *Water Let in on a Field of Alfalfa*, 1902

Page 70 (center): Maxfield Parrish, *Atlas Landscape*, c. 1907–1910

Page 71 (bottom left): Maxfield Parrish, *Formal Growth in the Desert*, 1902

Page 71 (top right): Maxfield Parrish, *The Reservoir at Villa Falconieri, Frascati*, 1903

Page 72 (top left): Renato Mucillo. Used by permission of the artist.

Page 72 (bottom): Renato Mucillo, *Formations*. Used by permission of the artist.

Page 73 (top left): Renato Mucillo, *Formations Study*. Used by permission of the artist.

Page 73 (bottom right): Renato Mucillo, *Laden Skies*. Used by permission of the artist.

Page 84 (center left): "Return to the City" image provided courtesy of Meredith Operations Corporation. McCall's®, 1948.

Page 84 (bottom left): Robert Levering, "Enjoy Life" (Canada Dry), *Life*, July 15, 1946

Page 85 (center): Robert Levering, "Fashion is for the Slender" (Pepsi). *Life*, October 26, 1953

Page 85 (bottom right): Robert Levering, "Refreshes Without Filling" (Pepsi), *Life*, June 13, 1955

Page 86 (left): Pruett Carter, Illustration for "The Stolen God," *The American Magazine*, Feb. 1936

Page 86 (center right): Pruett Carter, *Woman in an Interior*, 1926

Page 86 (bottom): Pruett Carter, Illustration for "Evening in Hawaii," *The American Magazine*, May 1937

Page 87 (center): Pruett Carter, *Through the Window*, c. 1940s

Page 88 (top left): Photo of Dorothy Day via Marquette Archives

Page 88 (bottom left): W. S. Merwin. Screenshot via Nicholson Baker.

Page 90 (top left): Rene Magritte and Georgette Berger, 1922

Page 90 (center left): Yon Gonzalez. Screenshot via Nicholson Baker.

Page 91 (top left): Dmitry Ageev. Used by permission of the artist.

Page 91 (center left): Photo of Chloe Blanchard, via Pinterest

Page 91 (bottom left): Mark Twain by Abdullah Frères, 1867, via Wikimedia Commons

Page 92 (center left): Elana Hagler, *Debra*, oil on linen, 40" x 30"

Page 92 (bottom left): Heinrich Vogeler, *Portrait of Martha Vogeler*, 1910, Worpswede, Haus im Schluh

Page 93 (left): Katya Gridneva. Used by permission of the artist.

Page 94: Albrecht Durer, *An Artist Drawing a Seated Man*, 1525, via Wikimedia Commons

Page 95: Lisa Lachri. Used by permission of the artist

Page 96 (top center): Fipsi Seilern, *Syrianna*. Used by permission of the artist.

Page 96 (center left): Léon Bakst, Portrait of Andrey Bely, 1905, The Ashmolean Museum, via Wikimedia Commons

Page 96 (bottom center): Sander Weeteling, via Unsplash

Page 97 (left): Photo of Emmy Rossum, via IMDb

Page 100 (center left): Leo Putz, *Wintersonne (Winter Sun)*, 1913

Page 100 (bottom left): John Singer Sargent, *Portrait of Robert Brough*, c. 1900, via Wikimedia Commons

Page 101 (center left): Rudolf Tewes, *Self-Portrait*, 1906, Kunsthalle Bremen

Page 101 (bottom left): Albert Marquet, *Portrait of Marcelle Marquet*, 1931, Musée des Beaux-Arts de Bordeaux, via Wikimedia Commons

Page 104 (center left): Maarten Schroder. Used by permission of the artist.

Page 104 (bottom left): Fremantle

Page 105 (center left): Ilya Repin, *Vsevolod Mikhailovich Garshin*, 1884, Metropolitan Museum of Art, via Wikimedia Commons

Page 109 (left): Robert Henri, *Gertrude Vanderbilt Whitney*, 1916, Whitney Museum of American Art, via Wikimedia Commons

Page 109 (right): Robert Henri, *The Beach Hat*, 1914, Detroit Institute of Arts, via Wikimedia Commons

Page 110 (bottom right): Photo of Dorothy Day via Marquette Archives

Page 116 (bottom right): Henry Hensche, *Ada in Sunlight*

Page 118 (top left): Writer Susan Sontag shown Jan. 11, 1964, via Associated Press

Page 120 (top left): A Portrait of Katharine Sergeant Angell White, White Literary LLC, via Wikimedia Commons

Page 121 (top right): Nina Leen / Shutterstock

Page 122 (left): Photo of Harold Ross, 1927

Pages 126: Masayasu Uchida, *Awakening on the Beach*, 1987. Used by permission.

Page 200 (top left and right): Helen Dryden, cover of May 1, 1929, issue of *Vogue*

Page 200 (bottom left): A. M. Hopfmuller, cover of May 1921 issue of *Shadowland*

Page 200 (bottom center): Frank R. Paul, cover of September 1927 issue of *Amazing Stories*

Page 200 (bottom right): Max Gundlach, cover of June 1931 issue of *Popular Mechanics*

Page 201 (top right): Ernest Hamlin, cover of July 19, 1948, issue of *Time*

Page 201 (center right): *Down East* cover for February/March 1956 by Eugene Shepherd, courtesy of *Down East*

Page 201 (bottom right): John Ralston Clarke, cover of October 1933 issue of *Silver Screen*

Page 202 (top left): Gretchen Dow Simpson photo, screen capture from "Gretchen Dow Simpson," video by Richard Goulis, NetWorks Rhode Island

Page 204 (top left): Via Reddit, r / redditgetsdrawn

Pages 204–205: Nicholson Baker. Original photos via Reddit, r / redditgetsdrawn.

Page 206 (top left): Franklin Booth, *Three Trees Fronting a University*, 1907

Page 206 (center left): Ian Sidaway. Used by permission of the artist.

Page 206 (bottom left) : Brian Kliewer, *Water View*. Artwork © Brian Kliewer

Page 206 (bottom right): Meindert Hobbema, *The Avenue at Middelharnis*, 1689, National Gallery, via Wikimedia Commons

Page 207 (bottom left and right): Nicholson Baker. Original photo by Roberto Serra / Getty

Pages 208–209: Nicholson Baker. Original photos via Reddit, r / redditgetsdrawn.

Pages 210–211: Nicholson Baker. Original photo courtesy Bob Adelman Estate

Pages 212–213: Nicholson Baker. Original photos via Reddit, r / redditgetsdrawn.

Page 214 (top left): Valentin Serov, *Isaac Levitan*, 1893, Tretyakov Gallery, via Wikimedia Commons

Page 214 (bottom left): Isaac Levitan, *Water lilies*, 1895, via Wikimedia Commons

Page 214 (bottom right): Isaac Levitan, *Birches. Forest Edge*, c. 1885, via WikiArt

Page 215 (bottom left): Isaac Levitan, *Over Eternal Quiet*, 1894, Tretyakov Galley, via Wikimedia Commons

Page 215 (bottom right): Isaac Levitan, *Evening at Volga*, 1888, via WikiArt

Pages 216–219: Nicholson Baker. Original photos via Reddit, r / redditgetsdrawn.

Page 220 (left): Trey Friedman, *Trees on a Line #49, Winter*, 2011, treyfriedman.com. Used by permission of the artist.

Page 220 (right): Trey Friedman. Used by permission of the artist.

Page 221 (left): Trey Friedman, *On Route 4*, 2004, treyfriedman .com. Used by permission of the artist.

Page 221 (right): Trey Friedman, *Corner Tree*, 2002, treyfriedman .com. Used by permission of the artist.

Pages 222–231: Nicholson Baker. Original photos via Reddit, r / redditgetsdrawn.

Page 232 (top left, top right, bottom right): Alexsandr Deyneka, © 2022 Artists Rights Society (ARS), New York / UPRAVIS, Moscow

Page 233 (center right): Gustave Baumann, *Pines Grand Canyon*, 1921, Art Institute of Chicago

Page 234: Landscape pastel sampler © Rochester Art Supply. Photography by David Hoffend.

Page 236 (center left and center right): Emma Colbert. Used by permission of the artist.

Page 237 (center left): Emma Colbert. Used by permission of the artist.

Pages 238–239: Karen Margulis, www.karenmargulis.com

Page 240 (top left): Félix Vallotton, *Evening on the Loire*, 1923

Page 242 (center left): Félix Vallotton, *Vase vert et bol blanc*, 1919

Page 242 (center right): Félix Vallotton, *Marigolds and Tangerines*, 1924, National Gallery of Art, Chester Dale Collection

Page 242 (bottom right): Félix Vallotton, *Laziness*, 1896, via Wikimedia Commons

Page 243 (center left): Félix Vallotton, *Chemin de la Croix-Rouge*, 1918

Page 243 (center right): Félix Vallotton, *Paysage à Marcillac*, via Wikimedia Commons

Page 243 (bottom left): Félix Vallotton, *Landscape in the Jura Mountains near Romanel*, 1900, Städel Museum, via Wikimedia Commons

Page 244 (top left): August Ahlborn, *Monastery complex on the Gulf of Naples near Sorrento*, 1837, via Wikimedia Commons

Page 245: Nicholson Baker. Original photo via Reddit, r/ redditgetsdrawn.

Page 246: Ian Fennelly. Screenshots via Nicholson Baker. Used by permission of the artist.

Page 247 (top right): Ian Fennelly. Used by permission of the artist.

Pages 248–249: Nicholson Baker. Original photo via Reddit, r / redditgetsdrawn.

Pages 254–255: Nicholson Baker. Original photos courtesy of Colby College English Department.

Page 266 (top left, center left): Alex Hillkurtz. Screenshots via Nicholson Baker.

Page 267 (top right, center right): Matthias Adolfsson. Screenshot via Nicholson Baker.

Page 267 (bottom right): Nicholson Baker. Original photo via Reddit, r / redditgetsdrawn.

Pages 270–271: Nicholson Baker. Original photos via Reddit, r / redditgetsdrawn.

Page 272 (top left): John Singer Sargent, Rose Marie Ormond, 1912

Page 272 (bottom left): John Singer Sargent, Italian with a Rope, c. 1900

Page 272 (top right): John Singer Sargent, Portrait of Ena Wertheimer: A Vele Gonfie, 1905, Tate, via Wikimedia Commons

Page 272 (bottom right): John Singer Sargent, Portrait of Mrs. Charles Hunter, c. 1902, Memorial Art Galley (University of Rochester)

Page 273 (bottom left): Angus Trumble, A Brief History of the Smile, 2004, Basic Books

Page 273 (center right): Mary Cassatt, Mother and Child Smiling at Each Other, 1908

Pages 274–275: Nicholson Baker. Original photos via r / redditgetsdrawn.

Pages 280–283: Nicholson Baker. Original photos via r / redditgetsdrawn.

Page 284 (center left, center right, bottom): John Whalley. Used by permission of the artist.

Page 285: John Whalley. Used by permission of the artist.

Page 286 (center): Screenshot via Nicholson Baker

Page 286 (bottom): Dina Brodsky. Used by permission of the artist.

Page 287: Dina Brodsky. Used by permission of the artist.

Pages 288–289: Frederick Brosen. Used by permission of the artist.

Pages 290–291: Judy Drew, www.behance.net/judydrew

Page 292 (top left): Albert Watson

Page 292 (center right): Nicholson Baker. Original photo by Albert Watson.

Page 293 (bottom): Nicholson Baker. Original photo by Alan Raia / Newsday.

Page 296 (top right): Félix Vallotton, Woman Reading, 1922, via Wikimedia Commons

Page 300 (bottom right): Nicholson Baker. Original photo via Reddit, r / redditgetsdrawn.

Page 301: Nicholson Baker. Original photo via Jack Mitchell / Getty Images.

Page 302 (top left): Jack Mitchell / Getty Images

Page 302 (center right): Richard Estes' Realism by Patterson Sims, Jessica May, and Helen Ferrulli, Portland Museum of Art and Smithsonian Institution

Page 302 (bottom): Richard Estes, Bus with Reflection of the Flatiron Building, 1966–1967, Marlborough Gallery, New York. © Richard Estes.

Page 303: Richard Estes, Jone's Diner, 1979, Marlborough Gallery, New York. © Richard Estes.

Pages 307–309: Nicholson Baker. Original photos via r / redditgetsdrawn.

Page 310 (bottom right): Nicholson Baker. Original photo by Todd Heisler.

Page 311 (center left): Nicholson Baker. Original photo © Saul Leiter Foundation.

Page 311 (center right): Nicholson Baker. Original photo via Alfred Eisenstadt / Life Magazine.

Page 311 (bottom left): Nicholson Baker. Original photo by Rie Hägerdal.

Page 311 (bottom right): Nicholson Baker. Original photo by Ramin Talaie.

Page 313 (center left): Nicholson Baker. Original photo by Scott Lapham, NetWorks Rhode Island, copyright Scott Lapham, scottlaphamprojects.format.com.

Page 320 (bottom left): Old Master Portrait Drawings: 47 Works, 1990, Dover Publications

Page 320 (bottom right): Andrea del Sarto, Head of Young Man, 1520, Louvre Museum, via Wikimedia Commons

Page 321 (top right): Leonardo da Vinci, Head of a girl, c. 1483, Royal Library of Turin, via Wikimedia Commons

Page 322 (center left and bottom left): Nicholson Baker. Original photo via Reddit, r / redditgetsdrawn.